2nd edition

# Art with an iPhone

## *A Photographer's Guide to Creating Altered Realities*

**Kat Sloma**

AMHERST MEDIA, INC. ■ BUFFALO, NY

◄ **Front cover.** *Luminous* (apps: ProCamera, Pixlr, Afterlight, Image Blender, Distressed FX, AutoPainter II, Snapseed).

◄ **Page 1.** *Triangulate* (apps: ProCamera, Snapseed, Image Blender, Decim8, Tangent).

Published by:
Amherst Media, Inc., P.O. Box 538, Buffalo, N.Y. 14213
www.AmherstMedia.com

Publisher: Craig Alesse
Senior Editor/Production Manager: Michelle Perkins
Editors: Barbara A. Lynch-Johnt and Beth Alesse
Acquisitions Editor: Harvey Goldstein
Associate Publisher: Katie Kiss
Editorial Assistance from: Rebecca Rudell, Carey Anne Miller, Jen Sexton
Business Manager: Adam Richards

ISBN-13: 978-1-68203-308-1
Library of Congress Control Number: 2017949329
Printed in The United States of America.
10 9 8 7 6 5 4 3 2 1

www.facebook.com/AmherstMediaInc
www.youtube.com/AmherstMedia
www.twitter.com/AmherstMedia

# Contents

▼ *Morning Hike* (apps: ProCamera, Stackables).

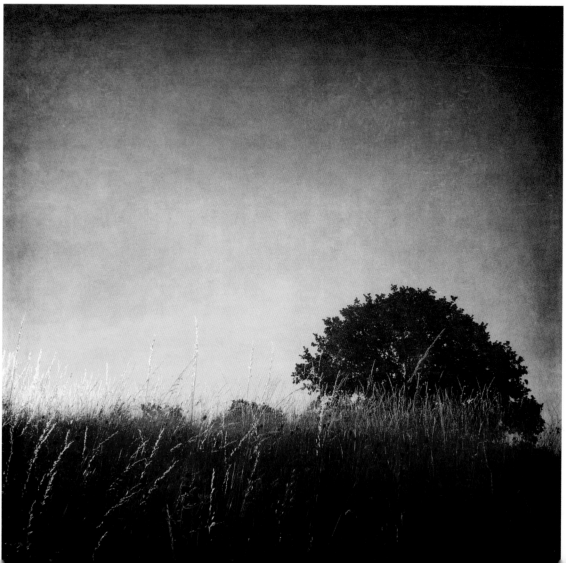

▲ *Awakening* (apps: ProCamera, Circular, Alien Sky, Stackables, Snapseed, Image Blender).

▲ *Disconnect* (apps: ProCamera, iColorama, Snapseed, Stackables).

# About This Book

If you have an iPhone, you have an amazing creative device in your pocket. Not only is it a convenient and capable camera, it has the tools to transform your photographs into something surprising and unique.

In writing this book, I hope to share the fun and excitement I've experienced with capturing photographs and creating photography-based art with my iPhone and iPad. My approach is a simple one. When I am out and about, I capture the best photographs I can using only the iPhone and natural light. There is something magical about always having a camera in your pocket. You see the familiar world anew.

Later, when I have time to experiment and play, I use apps to transform the photographs. I have no rules or expectations of outcome when I sit down to work with my photographs. An image may stay looking like a photograph, or it may become something more abstract. You'll see both in this book. The enjoyment is in seeing what appears as I change an image through a combination of apps.

The process I share in this book applies beyond the specifics of the device and apps. As with any book about technology, the specific features of the iPhone and the app screen shots will become outdated. That's okay—through multiple Apple devices and iOS revisions, I've found the apps function similarly and my general approach remains the same. You will be able to apply the concepts in this book regardless of the specific device or version of operating system you currently use.

Now you know where I'm coming from. Let's get you started creating your own photographic art on the iPhone.

ツ Kat.

## About the Author

Kat Sloma is a fine art photographer, writer, and instructor who developed her distinct contemplative style when she began using an iPhone to create photographic art. Her iPhone work has received recognition in the United States and internationally. A believer that everyone has the potential to share a unique point of view through art, Kat writes, teaches workshops, and speaks about the iPhone and other creative aspects of photography. She is the author of the popular eBook *Digital Photography Basics: Take the First Step Off Full Auto* and two editions of *Art with an iPhone: A Photographer's Guide to Altered Realities*. Kat currently lives in Corvallis, Oregon. To see more of Kat's work, visit www.kateyestudio.com.

The iPhone adds a new dimension to photography. Unlike previous photographic devices, where the camera was solely a capture device and images were processed later in a darkroom or on a computer, smartphones and tablets integrate both camera and processing capabilities into one device. While this integration provides an incredibly powerful platform for photography, it also creates challenges because these devices are not intended primarily to be cameras. These first few sections will address some housekeeping issues that arise when using an iPhone for photography, before getting into the camera and apps.

## Functionality

In creating a mobile device such as an iPhone, hardware manufacturers must trade off the size, space, cost, and functionality of the camera against other requirements, functions, and end-user expectations. Sensor resolution, sensitivity, lens, and other camera specifications change from device to device (iPhone, iPad, iPod Touch), generation to generation (iPhone 6, 6s, 7, and so on), and even front to back within a device. As such, the cameras in mobile devices are simple, small, and vary greatly—even within Apple's lineup of similar devices.

## Camera

If you don't know the camera specs for your specific device, look them up. Wikipedia and other online sites are a great source. Knowing the resolution difference between the front and back cameras enables you to make informed trade-offs when you take photographs. If you are debating a purchase, I recommend you look closely at the differences between the camera hardware on the different devices you are considering in order to understand the impact of your choice. These devices look similar on the outside, but the camera you are getting inside may be quite different.

> "One bonus of the simple iPhone camera is ruggedness."

Even though there are quality and performance trade-offs, one bonus of the simple iPhone camera is ruggedness. These devices are made to be handled, and there is not much you need to do to care for the camera. Invest in an impact case to protect it from damage from drops. To clean the lens, use a soft microfiber cloth. To prevent damage to the lens from scratches, tuck the phone into its own pocket without other objects (like keys) or place it with the camera facing away from other items.

◄ *Patchwork* (apps: ProCamera, Mextures, iColorama).

# 2. Power Management

I like to call my iPhone a "camera with a phone attached to it," but it's not the same as a dedicated camera. With my previous cameras, power management was as simple as getting into a routine of charging the battery after use and keeping a spare charged battery in the camera bag. With my iPhone, power management is not so simple.

When photographing and processing with apps on the iPhone, power is consumed by

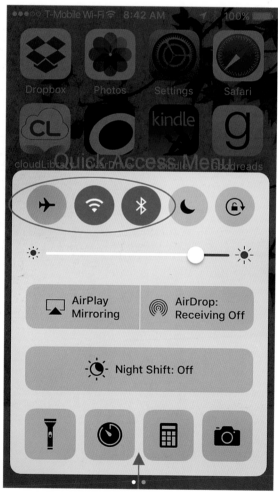

▲ Power options from the Quick Access Menu.

> "Apps running in the background increase power consumption – especially ones that use GPS and location services."

the continued, active use of the touch screen and camera functions. But the device is much more than a camera—it is GPS, phone, Internet connection, gaming system, word processor, and more. Running apps, searching for connections, providing turn-by-turn directions, and using the touch screen all take power. In order to conserve power for photography, and improve battery life in general, there are a few simple steps you can take.

## Close Apps

First, close apps you are not using. When you switch from one app to another, apps stay open in the background, waiting for you to return and pick up where you left off. Apps running in the background increase power consumption—especially ones that use GPS and location services. To close apps, double tap the home button and flick the app up.

## Turn Off Bluetooth and Wi-Fi

Second, turn off connectivity features you are not using. Turn off Bluetooth and Wi-Fi if you are not actively using them. If you can manage to live without your cellular connection, put your device in Airplane Mode. This can be done through the iPhone Settings app

▲ *Alter Ego* (apps: ProCamera, Snapseed, Image Blender, Stackables, Reflect, Tangled FX, XnSketch, Sketch Me!).

or the Quick Access menu. Simply flick up from the bottom of the screen and tap the icons to turn services on/off.

## Carry a Backup Battery

Third, carry a backup battery. Even after taking all of these precautions, a backup battery can be a savior. There are all sorts of backup batteries available, from cases with integrated battery packs to standalone batteries in various sizes. I always carry a small backup battery that fits in the palm of my hand and can charge my iPhone two or three times over if needed.

# 3. Transferring Files Between Devices

For editing, you might find the iPhone screen is a bit small and you'd rather work on the larger screen of an iPad. To do this, you will need to transfer image files between devices. When transferring files between devices, my goal is to move only the best images to the second device. I may take a hundred or more photos on a given day with my iPhone but only want to edit a few. I prefer to review the images on the larger screen of the iPad before I transfer, so that I can see the detail and choose the best version for editing.

I have tried many different transfer methods, from iCloud to various photo transfer apps, and have boiled it down to two methods: one for when both devices can connect to the cloud (Internet) and one for when they can't.

## Method 1: Cloud Connected Transfer

Moving images through the cloud via Dropbox is my preferred method of transfer. I transfer all photos from my iPhone to my Dropbox account via the Auto Camera Upload function of the Dropbox app. I can then review the uploaded images using the Dropbox app on the larger screen of the iPad. When I see an image I want to edit, I download that specific image to the iPad. This reduces file proliferation by moving just a few files out of many. Since Dropbox has apps for most operating systems, this method also works well if you want to transfer files between iOS, Android, or other types of devices.

## Method 2: Without Cloud Connection

When I don't have a connection to the cloud on both devices, Apple's AirDrop is a slower but useful method to transfer files between Apple devices. For both devices, make sure Wi-Fi and Bluetooth are turned on and set AirDrop to "Everyone" using the Quick Access menu. Next, go to the Camera Roll of the sending device and select the image(s) you want to export and tap the Export icon. When the Export menu opens, tap the AirDrop icon. The sending device will search for other nearby devices, and will show an icon for each one found. Tap the icon for the device you want to send to, and the photo(s) will be transferred.

> "For editing, you might find the iPhone screen is a bit small . . ."

▼ *Beamed Up* (apps: ProCamera, Snapseed, Image Blender, Decim8, XnView Photo FX, Big Photo).

# 4. File Management and Storage

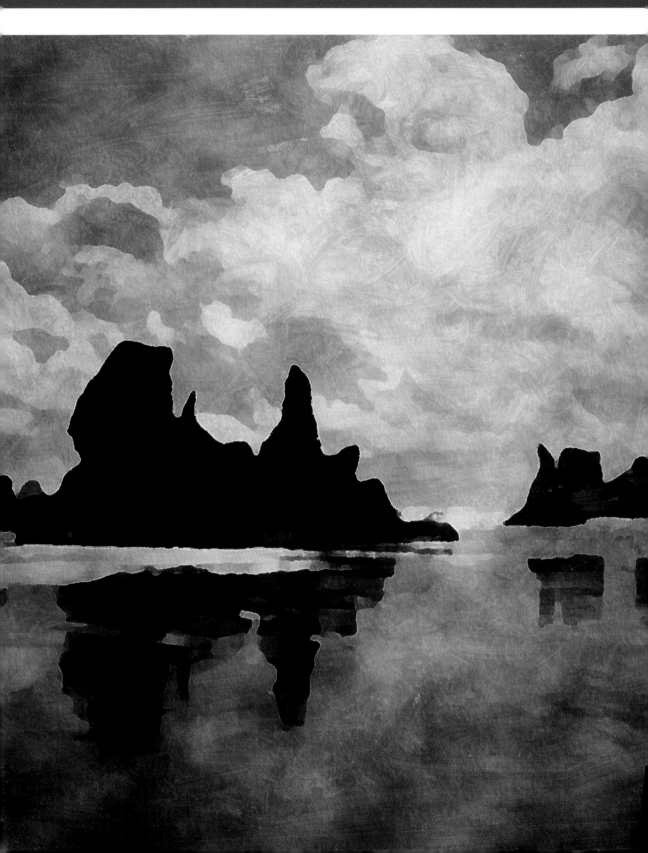

With increasing storage on mobile devices, it might be easy to consider your iPhone as a reasonable place to store your image files long term, but don't. Your iPhone isn't the same as a computer archive, since it is more easily lost or damaged. It becomes difficult to find specific images when you have many thousands of images on your Camera Roll. Photography apps may become sluggish or crash when the Camera Roll gets too large.

## iPhone as Working Storage

Think of the iPhone as working storage. Capture, edit, and share on the device, but move your image files to a computer or the cloud for permanent backup. I keep the number of image files on my devices under a couple of thousand. This keeps apps functioning well, I can still find specific files I want in the Camera Roll, and I rest easier knowing my older images are safely archived on the computer, which has both local and cloud backups. I can always transfer images back to my iPhone for editing, if desired.

## Transferring Files to a Computer

To transfer files between your iPhone/iPad and a computer, connect the device with a USB cable and access it as you would any external USB storage device. Before you attempt to do any file manipulation, wait until any iTunes backup or sync completes, eject the iPhone in iTunes, and then proceed with the instructions below.

In Windows, access the device through Windows Explorer. Look for the device name, navigate to the Internal Storage folder, and then to the DCIM folders below. Your images and videos reside in the folders below DCIM. When you open the folders with the image files, click to select images, then right-click to copy them to a new location (or delete). Use Ctrl-A to select all files in the directory for copying or deleting. You will not be able to delete the directories, just the files.

On a Mac, go to your Applications folder and open the Image Capture app. In the devices column on the left, you will see your device. Select the files of interest to import or delete.

A direct connection to your computer is the quickest method for deleting many images files at once from the iPhone.

## Transferring via Dropbox

If your computer is connected to your Dropbox account, transferring through the cloud via Dropbox will also work for transfer to the computer.

◀ *Castles in the Sand* (apps: ProCamera, Snapseed, iColorama).

## Flexibility in Camera Apps

While the typical digital camera controls are not available on the iPhone, using a third-party camera app will give back some of the control missing in the native iOS app. Once you find a camera app you like, use it exclusively for taking photos. (Ignore the camera options provided in editing apps; these typically have limited functionality.)

▼ *Where Do We Go From Here* (apps: ProCamera, Snapseed, Handy Photo, AutoPainter, Glaze, iColorama, Image Blender).

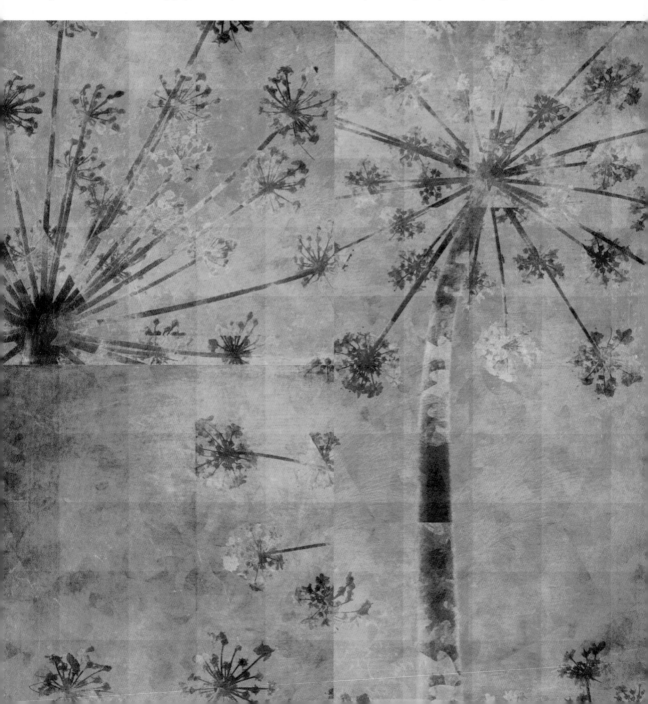

There are several features I consider critical in a camera app. All of these are available in Pro-Camera, the camera app I reference throughout this book.

## Independent Focus and Exposure Settings

If your camera app uses one tap to set both the focus and exposure point, it can result in a poor exposure (images that are too bright or too dark). Being able to set independent focus and exposure zones within the frame is the biggest key to getting good photographs out of your iPhone camera across a broad range of situations.

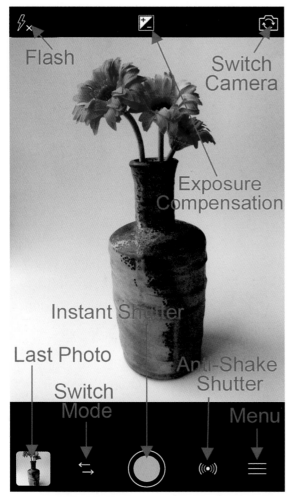

▲ ProCamera main screen.

> "For maximum flexibility in post-processing and printing, you want your captured image files saved as high quality."

## High Quality Files

For maximum flexibility in post-processing and printing, you want your captured image files saved as high quality. In ProCamera, you have a choice of file types: JPEG, TIFF and RAW. You can set your file format from either the Menu screen or File Format option under Settings.

If you are limited on storage space, use the JPEG file format at 100 percent compression setting. If you have plenty of storage space, use the TIFF uncompressed format for best image quality. Most editing apps will load TIFF files, but if not, you can convert the files by loading into the Snapseed app (covered later) and exporting as a JPEG file.

## Stabilization or Anti-Shake Shutter

Most blurry photos from smartphones are due to the user moving the camera while the photograph is being taken. A stabilization or anti-shake shutter feature prevents the shutter from releasing until the device is stable enough that user movement won't cause blur.

## Aspect Ratio Selection

The effectiveness of an image's composition is greatly affected by the final frame. Being able to change the aspect ratio of the frame from a square (1:1) to a rectangle (3:2, 4:3, etc.), is a powerful composition tool available to photographers using iPhones.

# 6. Controlling Exposure and Focus

## Setting Focus and Exposure Independently

Independently setting the focus and exposure can yield a huge improvement in your iPhone photographs. The typical camera app settings, which put focus and exposure in the center, work in situations where you have an evenly lit scene and your subject is in the center of the frame, but this is a rare situation in creative photography.

> "If any areas in the image appear too bright or you want to darken the scene, move the exposure target to a brighter area of the screen."

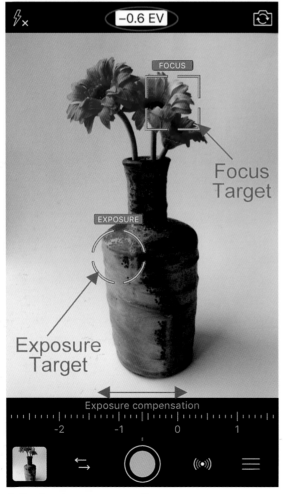

▲ Targets and exposure compensation.

## To Set Focus and Exposure Independently in ProCamera

First, tap the screen within the frame, away from the center, where you want to set the exposure. A yellow circle within a blue square, the exposure and focus targets, will appear where you tapped.

Next, drag the focus target (blue square) to the location where you want to have the app set the focus. The target will blink as the focus is reset. The exposure target (yellow circle) will stay where you first tapped.

When the image looks correct, tap the Shutter icon to take the photograph. The focus and exposure targets will stay in the same place for the next shot, unless you move them again or close the app.

## Setting the Exposure Target

When you move the exposure target, the app will shift the overall exposure accordingly. If any areas in the image appear too bright or you want to darken the scene, move the exposure target to a brighter area of the screen. To darken, the opposite applies. To remember where to move the target, here is a

mnemonic: If it's too bright, target bright; if it's too dark, target dark.

## Exposure Compensation

To further fine-tune exposure, use exposure compensation. Tap the Exposure Compensation icon at the top of the screen, then slide your finger left or right along the dial under the image. Once opened, the exposure compensation dial will remain open at the last chosen setting. To reset to zero and close the window, double-tap the setting dial.

## Lean Toward Underexposure

Always tend toward underexposure. There is more information in the shadows that can be retrieved in post-processing, while information in overexposed, white areas is lost.

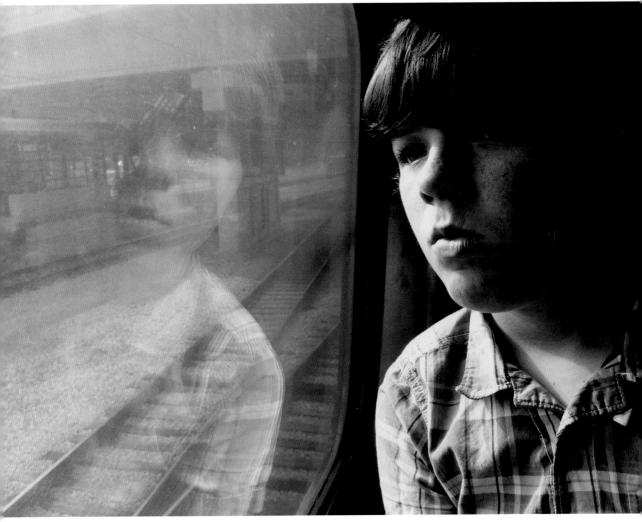

▲ *Boy in Contemplation* (apps: ProCamera, Alt Photo).

# 7. Getting Sharp Focus

## Focus Is Tricky on iPhones

Anything can look sharp on the iPhone's small screen, but viewing on a larger screen often reveals poor focus. A lot of things can be repaired in post-processing, but focus isn't one of them. It is important to get the focus right from the start. Here are a few ways you can improve your ability to get sharp focus on your iPhone.

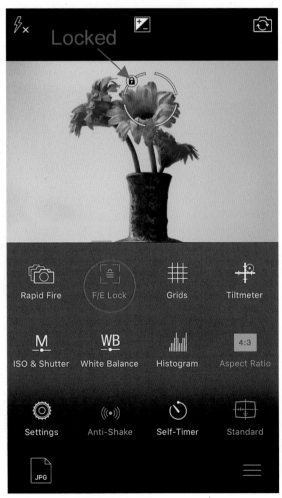

▲ Setting focus/exposure (F/E) Lock.

## Set Your Focus Point

Set the focus point on your intended subject. The iPhone camera does not have an infinite depth of field, which becomes obvious when there's a large distance between the subject and background. Don't assume that leaving the focus in the center will be adequate.

## Take Multiple Images

Setting the focus point is not precise. Slight movement of the camera, subject, or focus target can result in loss of focus. Once you have the focus set, take several images. Upon later review, check for subtle differences in the focus and pick the best one.

## Use Focus/Exposure (F/E) Lock

If you are having trouble getting the focus to hold on a specific point, you can lock the focus (and exposure) using the F/E Lock mode in ProCamera. With the F/E Lock off, the focus/exposure are reset when the iPhone moves. With F/E Lock on, the focus/exposure are set manually and held—even if the device moves.

To set the F/E Lock, fill the frame with an object at a similar distance as your point of focus. Tap to set the focus/exposure targets, which will have a lock symbol on them. That indicates they will not change their settings until you manually move them on the screen.

Now, reframe the image as you like, moving the camera so your subject is in focus at the locked range. You can move the exposure target as needed to reset exposure correctly, while the focus remains fixed.

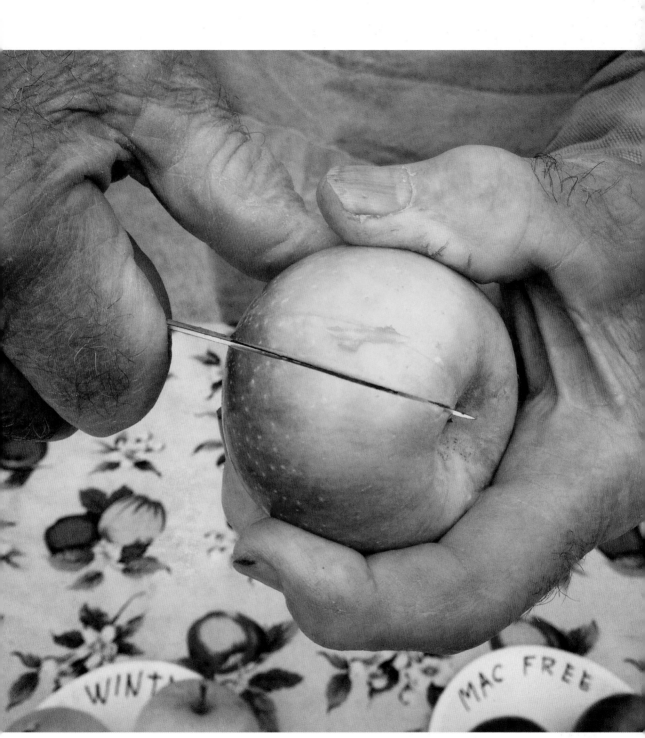

▲ *The Apple Man's Hands* (apps: ProCamera, Snapseed).

## Anti-Shake Shutter

Unless you are photographing a moving subject or scene where timing is of the essence, use the Anti-Shake Shutter setting available in ProCamera. If you are moving too much

## Instability Icon

Many iPhone photographs are ruined because of camera movement by the user, resulting in blurry, slightly out-of-focus images. Improving your stability will improve your images. I have found I rarely have issues with camera shake using these techniques.

after you press this shutter, you will see the Instability icon in the frame. The photograph is not taken until the device is stable enough to avoid camera shake.

## Use a Light Touch

Even with the Anti-Shake Shutter setting active, you can improve your stability when shooting by using a light touch as you tap the screen. It is not necessary to jab the screen forcefully to set focus, exposure, or tap the shutter. You can reduce the movement induced due to tapping the shutter by holding your finger on the Shutter icon, lifting it only when you are stable and ready for the shutter to release.

## Firmly Hold and Tuck

Anything you can do to reduce the movement of your arms and hands will increase your stability. Hold your iPhone securely in your non-dominant hand wrapping your fingers around the device, and tuck your elbows in along the sides of your body, so that only your forearms are held out. Use your dominant hand to set the focus and exposure, then hold the camera firmly to increase stability as you take the image using the Anti-Shake Shutter.

## Rest on Something

Resting your elbows, or the iPhone itself, on a fixed surface (a railing, the ground, or your knees if you are sitting) can increase the stability of the camera. Small, portable tripods are also available for the iPhone.

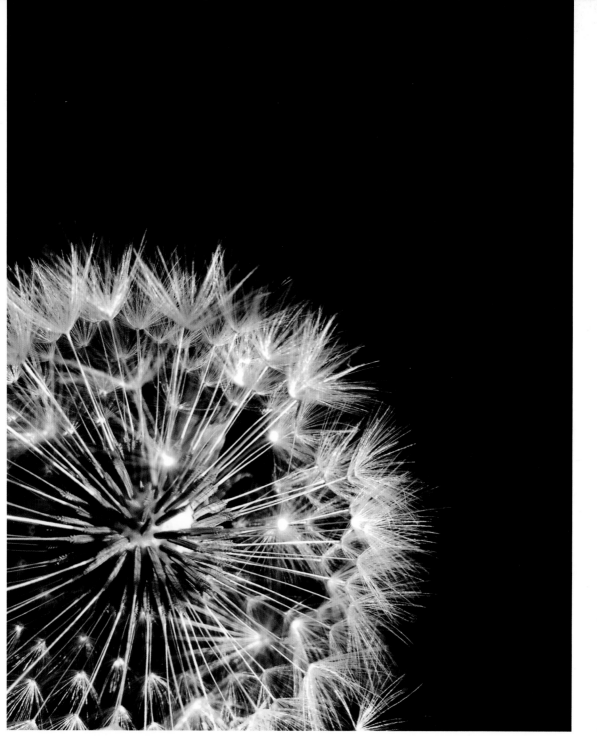

▲ *Dandelion* (apps: ProCamera, Snapseed, Handy Photo, Big Photo, Distressed FX).

## Take Multiple Images

Again, taking multiple images of the same scene will increase your chances of getting a sharp image. As you improve your stability through use of the Anti-Shake Shutter and holding the camera properly, you will find you need to take fewer images to avoid camera shake.

# 9. Capturing Moving Subjects

The previous methods for focus, exposure, and stability work great with static subjects. If you are photographing subjects that move, like children or animals, the Rapid Fire mode in ProCamera is a great tool to overcome the shutter lag you experience with an iPhone camera.

When Rapid Fire mode is set, you can press and hold the shutter and the app will continuously take photographs and buffer them for processing. A small red icon appears above the Last Photo window showing how many images are left to process and save. This allows you to quickly take many photographs of a moving subject, so you don't miss out on the action.

## Set the Focus and Exposure

If you have enough time, set the focus and exposure in the normal manner for your desired composition. This will give you the best overall results. If you can, anticipate the action and begin taking photographs before the moving object is in the perfect position.

▲ Select Rapid Fire in Menu.

▼ The final image (facing page) looks calm and peaceful, but the situation was dynamic, as can be seen in the series below.

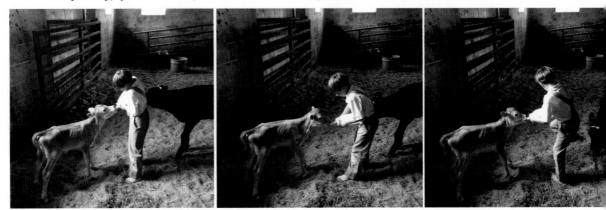

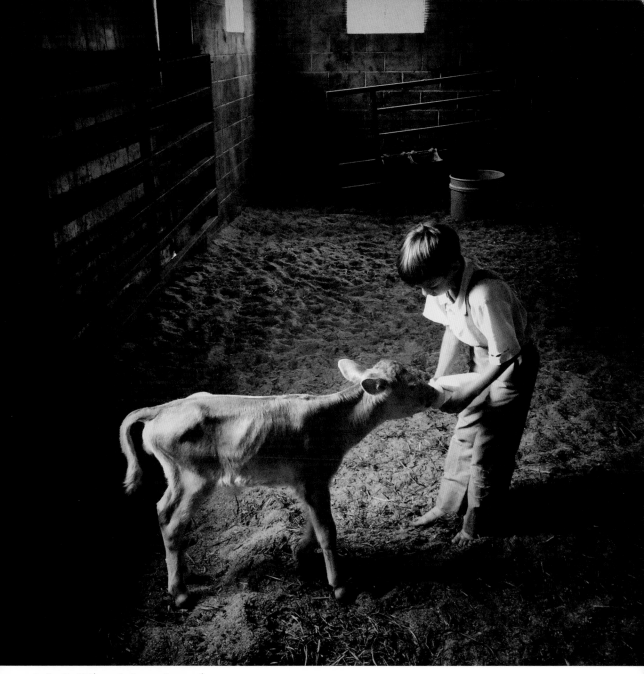

▲ *One Day Old* (apps: ProCamera, Snapseed).

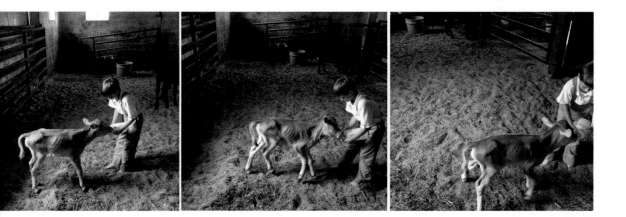

# 10. Working in Bright Conditions

Using a smartphone camera brings challenges when taking photos in bright light. First, it can be difficult to see your screen because of the reflected light. Second, the iPhone's wide angle lens is prone to lens flare.

## Working Through Reflections

If you can't see your screen due to reflected light, the easiest thing to do is shift your angle or shade the screen with your hand.

▼ *Low Tide* (apps: ProCamera, Stackables).

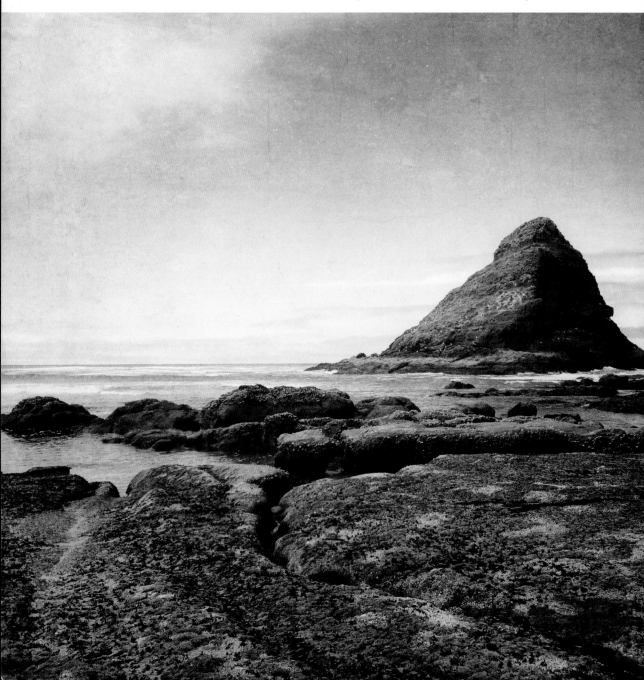

If neither of these is possible, try this trick: Overexpose to compose. High contrast images are easier to see on the screen in bright conditions. Intentionally overexpose the image to see high-contrast elements through the reflections, and once the image is composed as you like, reset exposure before you tap the shutter.

## Take Multiple Images

Once you believe you have your composition and settings dialed in, take multiple images, slightly moving your frame and adjusting the exposure with each. When you cannot see well enough in the bright sunlight to perfect your composition and exposure, it's a good idea to give yourself multiple images to review.

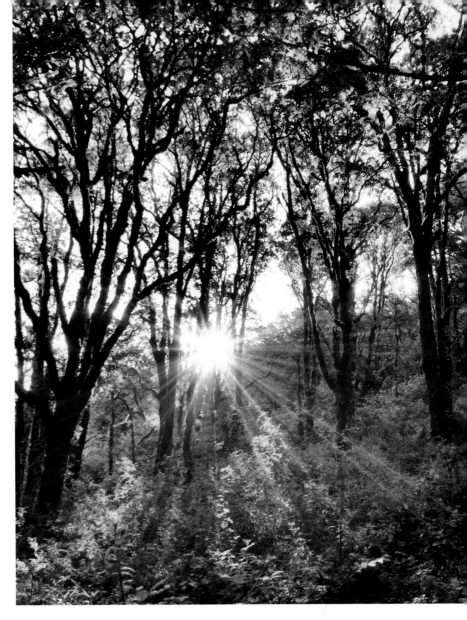

▲ *Early Riser* (apps: Pro HDR, LensFlare, Snapseed, XnView Photo FX).

## Reducing Lens Flare

Lens flare, bright blobs, or streaks of light that are created when you photograph into the sun or a bright light source cannot easily be corrected in post-processing. Shifting the camera slightly, so that the light source is either outside of the frame or behind another object, can eliminate most lens flare. You can also reduce the light reaching the sensor by shading the lens with your hand as you take the photograph. Just make sure you don't end up with fingers in your image!

## Add More Flare

If you like the look of flare, you can add or enhance it with an app. In the image *Early Riser*, shown here, there was some lens flare in my starting image, and I enhanced it by using the LensFlare app.

# 11. Selecting an Aspect Ratio

One of the most exciting things about flexible camera apps like ProCamera is the ability to change your aspect ratio at the time of taking a photograph. Instead of photographing in a single format based on the camera hardware itself, a limitation of most cameras in the past, you can now adjust frame aspect ratio in real time in your camera app. This flexibility provides a powerful way to explore and understand the relationship between the frame's aspect ratio and the composition.

## Differences in Ratios

Aspect ratio is the ratio of the length to the width of the frame. The larger the ratio be-

▼ *Sea Star* (apps: ProCamera).

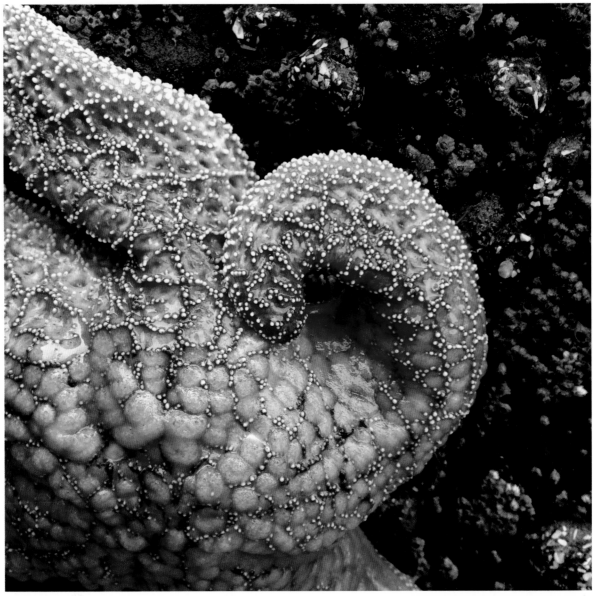

▶ Alternate compositions impacted by the aspect ratios used.

tween the sides, the more strongly rectangular the frame is. An aspect ratio of 1:1 indicates the sides are equal (the frame is a square) while 3:2, the typical dSLR format, indicates a rectangle where one side is 50 percent longer than the other.

## Adjusting Aspect Ratio

To change aspect ratio in ProCamera, tap the Menu icon and then tap the Aspect Ratio icon. Each successive tap on the Aspect Ratio icon will change the aspect ratio through a menu of options. Tapping on the Menu icon again or anywhere on the screen will close the menu and allow you to compose a new photograph. ProCamera will hold your last aspect ratio setting until you change it, even if the app is closed and reopened.

Once you've selected an aspect ratio, the frame shown on the iPhone screen is in that format, so you can see and compose as you photograph.

The resulting image file is saved in the chosen aspect ratio, as well. As you change away from the native camera aspect ratio, which is 4:3, you utilize fewer of the camera's pixels. At 4:3, the photograph utilizes all of the camera's pixels (4032x3024 for 12MP cameras). At a 1:1 aspect ratio, you would utilize 3024x3024 pixels. The same reduction would happen if you cropped a 4:3 image to 1:1 in post-

processing, but by changing aspect ratio in-camera, you have the benefit of viewing the image in real time and making any desired adjustment to the composition.

# 12. Composition

Composition is the arrangement of the elements within the frame of a photo. The elements in a photograph are physical things in the 3-D world, like a bicycle or a cloud, but they also have a graphic impact in the 2-D image as line, shape, and/or color.

## A Powerful Tool

Composition in iPhone photography is not fundamentally different than composition in any other type of photography. What is different is the amount of control you have in your equipment to affect the relationships between the elements. With an iPhone, you have fewer tools available to you than a dSLR, where you might choose to use a different lens or depth of field. Having fewer choices can provide a powerful creative catalyst, engaging and challenging you to create interesting images through framing, point of view, and post-processing.

## Basics of Good Composition

The basics of good composition start with answering a simple question: What are you photographing? Before you can compose an image to tell a story, you have to know what story you want to tell. What caught your eye? What made you want to pull your iPhone out of your pocket? Try to go beyond the

◀ *Together* (apps: ProCamera, Stackables).

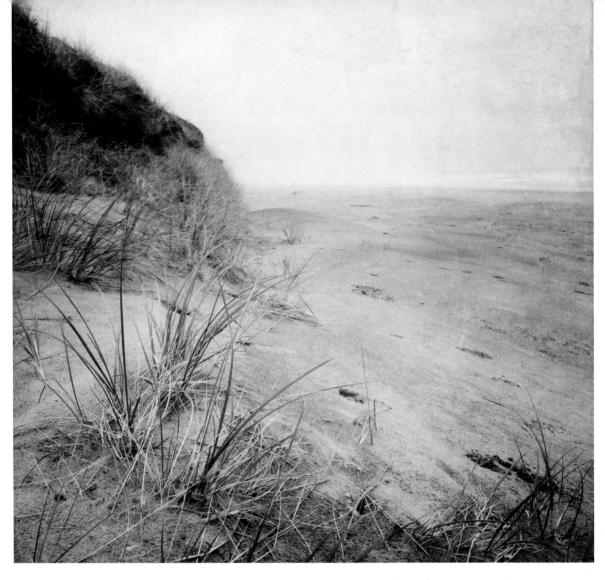

▲ *Washburne Beach* (apps: ProCamera, Stackables).

obvious—the subject—to study what about the subject caught your interest.

If you are photographing a bicycle, what is it about the bicycle that you are photographing? Is it the way the light is catching the frame? Is it a contrast of color or shape with its surroundings? Answering the question of what exactly you are photographing is the start to creating a composition to tell your story effectively.

## Making Choices

Once you know what you are photographing, you have choices to make. What stays in or out of the frame? What aspect ratio do you use? What point of view do you choose? How do you balance all of the elements that are available to you?

The following sections cover the compositional tools available as you photograph with an iPhone—but keep in mind that they apply equally well to photography with any type of camera. If you can learn to create effective compositions with the simple iPhone camera, your compositional skills using other cameras will improve, too.

# 13. Visual Impact and Balance

Once you have decided to photograph something, it can be easy to see only the subject that caught your eye and downplay the compositional impact of the surrounding elements, which also end up in your frame. You might think if something caught your eye, it will catch your viewer's eye too, right? Not necessarily. To create an effective photograph, you balance all of the elements, learning to see your intended subject in relation to everything else within the frame.

Balance in a photograph is not so different from balance in the real world. The 3-D world we inhabit is filled with physical things with volume and mass. In the 2-D world of the photograph, these physical things become

| Higher Visual Impact | Lower Visual Impact |
|---|---|
| Bright/warm colors | Dark/cool colors |
| Brightly illuminated | Shadowed |
| High contrast | Low contrast |
| In focus | Out of focus |
| Edge of frame | Center of frame |
| Isolated object | Dense, cluttered objects |
| Break in pattern | Pattern itself |
| Complexity | Blank space |
| Human faces | Inanimate objects |
| Words, numbers | |

▼ *Christmas Valley Sand Dune* (apps: ProCamera, Snapseed, Distressed FX, Image Blender).

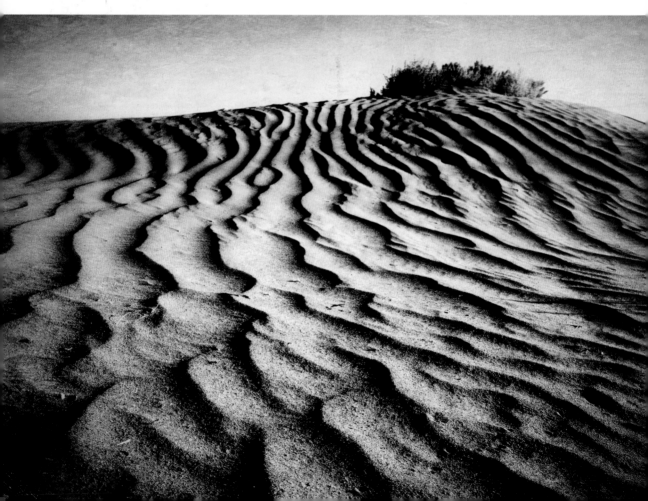

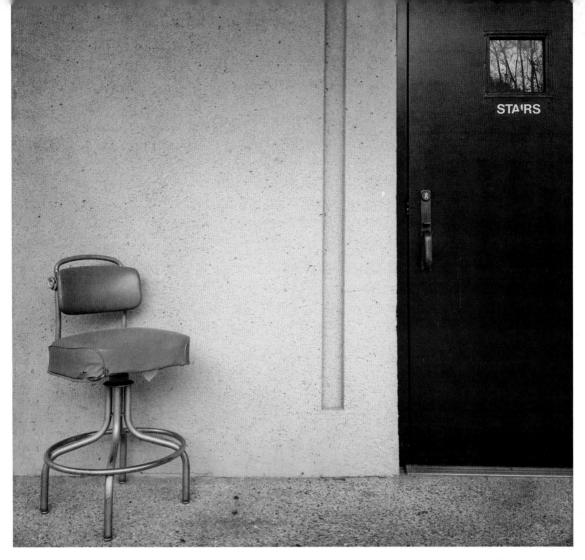

graphic elements—lines, colors, and shapes. The relative visual impact of the graphic elements (how strongly each element attracts the eye of the viewer) affects the balance of the composition and the intended message.

▲ *Guarding the Door* (apps: ProCamera, Stackables).

## Symmetry and Asymmetry

Balance can be symmetric or asymmetric. To achieve symmetric balance within the frame, the image is composed with elements of similar visual impact at the left/right or top/ bottom. Images with symmetric balance tend toward static and calming.

More typically, balance is asymmetric, where the image is composed with elements of varying visual impact distributed throughout the frame. This type of balance is usually more dynamic and energetic than symmetry.

## Balance in Post-Processing

It is important to note that the visual impact of elements in a photograph can be significantly affected during post-processing. Changing the color tones, adjusting contrast, or removing unwanted elements will all affect the relative visual impact, giving you further control of the final balance that is achieved in your composition.

# 14. Allowing Space

▲ *Remember* (apps: ProCamera, Snapseed, Distressed FX).

Since objects in the real world become graphic elements in the photograph, it's also important to consider space as a graphic element with visual impact. In a photograph, space is created by a continuous area that has an absence of distinct objects. Space in a photograph is never entirely void; it is always filled with something—whether color, texture, or pattern. A brick wall, the boards of a fence, or an expanse of concrete can all provide space in a photograph because they are viewed as one element that acts as a con-

tinuous backdrop or contrast to other distinct elements.

▲ *Welcome Winter* (apps: ProCamera, Stackables).

## Direct the Viewer

This contrast between space and the other elements makes it a useful compositional tool. The more space you include, the easier it is to point the viewer to what you think is important. If you have a large expanse of space, the eye will naturally go to the subject—the object in contrast—rather than the space. Inclusion of space within the photograph gives both the subject and the eye a place to rest, which can create a peaceful and cohesive composition. It can also provide a distraction if the visual impact of the space is not balanced well against the other elements.

## Compositional Choices

Including space in a photograph is not always possible or desired. Filling the frame with elements does not mean the photograph will be overly complex or cluttered. It is a compositional choice, like any other. On the iPhone, where you don't have the range of control through optics or settings that you do on other cameras, allowing space can be an effective compositional tool.

# 15. Point of View

## The Impact of Angles

Point of view is one of the most powerful compositional tools in a photographer's toolbox. The angle from which you aim the camera impacts almost everything in the composition—the way the subject is captured relative to the light, the relationship of the individual elements to one another, and the relationship of the subject to the background.

## Change the Spatial Relationships

Changing your point of view allows you to change, within the frame of the photograph, the relative position of objects that are fixed in the real world. You can't move a building or the tree planted beside it, but you can move yourself and change the appearance of the relationship between the two static objects within the photograph. From one angle, two objects are side by side; from a different angle, the two objects can be separated.

## Point of View and Control

Point of view allows you some manner of control. By shifting your point of view, you can create separation or connection between objects—even when you have no ability to move them in real life. You can clear a cluttered background by looking up or down on your subject. You can isolate your subject by moving to the left or right. Many of my tree photographs are taken looking up, creating the impression of an isolated tree or branch. In reality, many of these trees are in crowded and cluttered environments, like a parking lot or forest.

## Experimentation

An iPhone is a fantastic tool for experimenting with point of view because it is small and maneuverable.

◄ *Hello, Sunshine* (apps: ProCamera, Handy Photo).

▲ *Heceta Head Lighthouse* (apps: ProCamera, Stackables).

You can photograph from underneath a subject or hold the phone out over an edge to capture a perspective you wouldn't otherwise see. Since most of the photographs taken in the world are from human eye level looking straight at a subject, presenting a scene or subject from a distinctly *different* point of view can surprise and engage the viewer. A more interesting photograph is often available just a few feet higher or lower than eye level—or a step or two away.

# 16. Line and Frame

The interaction of line and frame has a dramatic impact on the effectiveness of the photograph. The frame itself is the outmost edge of the photograph, where the image ends and something else—a mat or blank space—begins. "Framing an image" is the process of deciding how to place the scene you are capturing within those edges of the photograph. This process starts with choosing the aspect ratio of the frame in your camera app, moves through the other compositional decisions (such as point of view and balance), and ends with a decision about where exactly you will place the edges of the frame at the time you take the photograph.

▲ The same subject framed in different ways.

## The Impact of Shifts

For any one scene, from any one point of view, there are an infinite number of ways to frame an image. Changes of aspect ratio or slight shifts of the frame—left, right, up, down—affect what is in or out of the photograph. In turn, this affects the balance of elements and the overall visual impact of the image.

## Lines

While all of the elements in a photograph interact with the frame, the lines have the strongest relationship with the edges of the frame, affecting the energy in the photograph. Lines parallel to the edge of the frame are more static, while strong diagonals are dynamic. Lines lead the eye through the frame, so you must consider how the viewer may be led. Are the lines leading to something or away from something? Into the frame or out of it?

Lines in a photograph are not always explicit; they can also be implied. A person looking or an object moving in a direction within the photograph creates an implied line. Anything repeated, no matter the shape, creates an implied line.

Experiment with line dynamics by changing aspect ratio, orientation (horizontal or vertical), and tilt.

"For any one scene, from any one point of view, there are an infinite number of ways to frame an image."

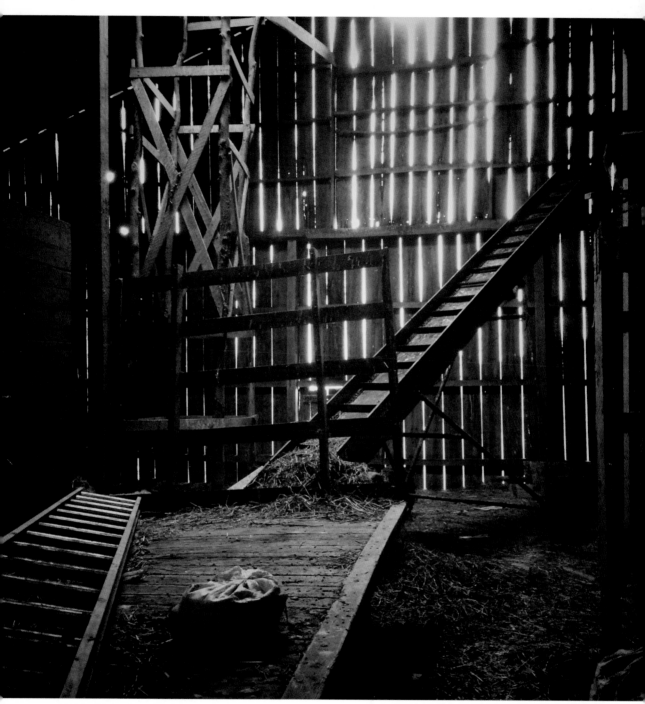

▲ *Hayloft* (apps: ProCamera, Snapseed).

Composition results as much from what you leave out of the frame as what you keep in it. Once you decide what you are photographing, you can assess what can be eliminated from the frame. If an element within the frame doesn't help you convey what you intend to convey, it doesn't belong.

## Point of View and Framing

Since I am typically photographing out in a real-world environment without control of the relative placement of elements, I use a process of elimination to create compositions. I use the tools of point of view and framing, take a photograph, and review the resulting image to make an assessment of what elements can be eliminated.

## The Process Described

I will use the photograph *Memory of Autumn* (facing page) as an example to recount my process. First, what was I photographing? I wanted to capture the unique connection between the fallen leaves viewed through the roof of a bus shelter, and tree they came from. Next, I photographed the first image (top left), which includes both the bus shelter window frame along with the leaves and tree.

I decided the heavy, dark window frame of the bus shelter was a distraction from the interesting interaction between the leaves and the tree. I shifted my point of view slightly,

◀ First and second attempts.

▲ *Memory of Autumn* (apps: ProCamera, Snapseed).

composing the image without the bus shelter frame. In reviewing this image, I see the inadvertent capture of the building behind the tree along the lower left side. When you shift the point of view, it is easy to introduce new distractions.

Finally, I shifted point of view slightly to frame the scene without any part of the bus shelter or building, including only the elements of leaves and tree. This final image conveys the relationship I was seeking between the tree and leaves. In post-processing, I adjusted the color tones and the image was complete.

# 18. Motion Blur

If you want to capture motion blur or practice other long-exposure techniques, you will need a dedicated app, since you can't control shutter speed directly on the iPhone. You can get great motion blur and light trails with the iPhone, but the long exposure apps don't work exactly the same as a long shutter speed in a dSLR. Instead of keeping the shutter open for a specified time, the apps take multiple photographs throughout a specified capture duration, blending them together into a final image. The result is slightly different than a long exposure on a dSLR, but just as unpredictable and fun.

My favorite long-exposure app is Slow Shutter Cam. This app has focus and exposure targets that are similar to ProCamera, allowing you to tap and set focus and exposure independently prior to taking the photograph. The app takes the capture duration into consideration, providing a brightness in the blended and blurred photograph that is based on your exposure setting.

## Capture Modes

There are three modes: Motion Blur, Light Trail, and Low Light. Each mode has a different Blur Strength or Sensitivity setting, and a selectable Shutter Speed (capture duration). In Motion Blur mode, the Blur Strength setting determines how the individual images are combined, resulting in less or more blur for the same capture duration.

## Motion Blur Mode

I use this app primarily in Motion Blur mode with intentional camera movement. As with any motion blur or camera movement photography, the results are not predictable. Depending on your chosen scene and desired effect, you will want to play with the Blur Strength and Shutter Speed settings, along with movement of the iPhone camera. For the image *Cattail Dance*, there was left-to-right movement of the cattails from the wind while I was moving the iPhone in an

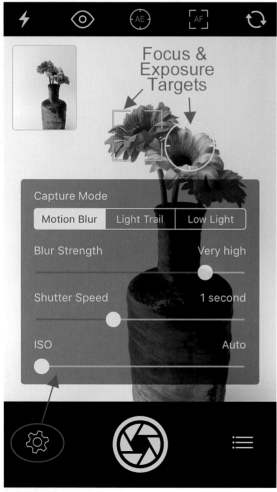

▲ Set targets and choose mode.

S-shaped up-and-down motion as well. The combination of the two types of movement leads to the impression of a graceful dance.

To get this one image I took 57 photographs, playing with different compositions, camera movements, and app settings in each.

▼ *Cattail Dance* (apps: Slow Shutter Cam, XnView Photo FX).

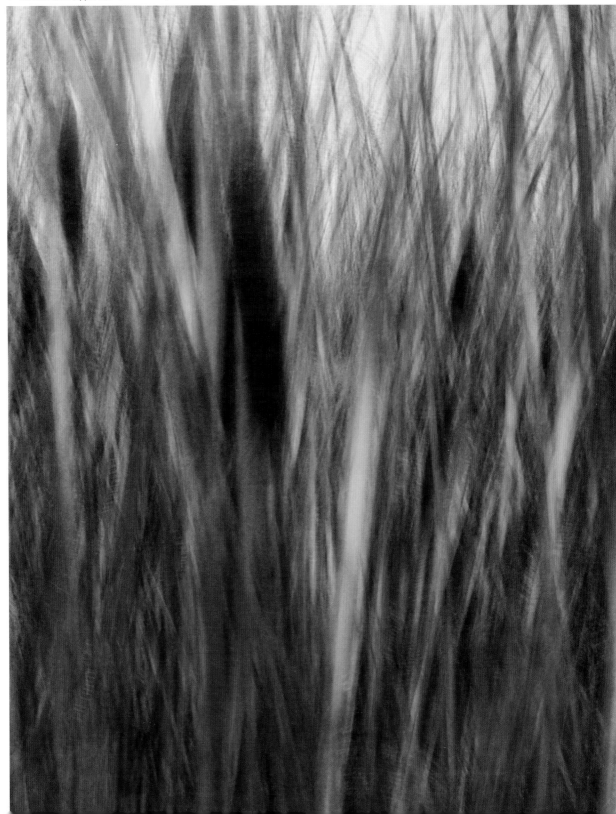

# 19. High Dynamic Range

**D**igital cameras have a limited range of light and dark they can accurately capture, so high-contrast scenes can be a challenge. The iPhone is no exception. If you expose to maintain detail in the brightest highlights, the shadows can be too dark. If you expose for detail in the darkest shadows, the highlights can be overexposed. High Dynamic Range (HDR) apps can help solve this problem. HDR apps blend two images, a light and a dark exposure of the same scene, to create a final image that has detail from the darkest to lightest areas of a scene.

## High Dynamic Range Apps

There are many HDR-specific camera apps available for the iPhone, but I like the convenience and function of the built-in HDR mode for the ProCamera app, available as an in-app purchase.

To access HDR, tap the Switch Mode icon and select the HDR camera. You know you are in the HDR mode when the Instant Shutter icon sports a rainbow. To take a photo, compose your image, tap to focus and then tap the shutter button. Be sure you are stable when you tap the shutter button. The app

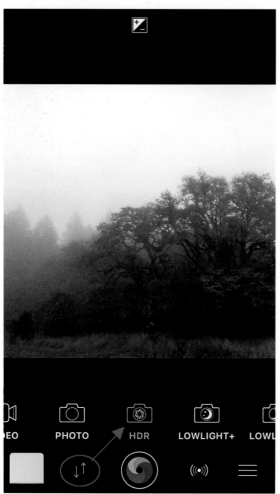

▲ Switch to VividHDR Mode.

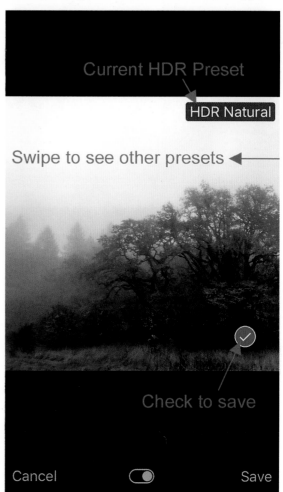

▲ Select and save image with preset.

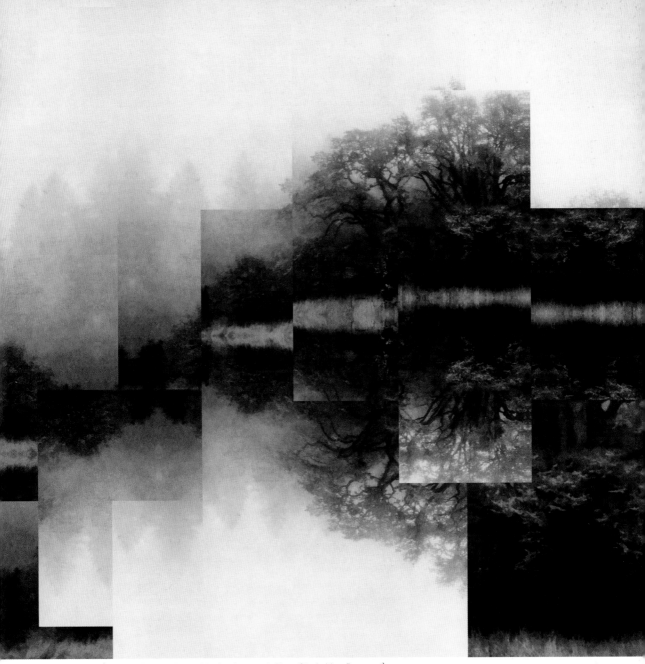

▲ *Inexpressible* (apps: ProCamera, Image Blender, Snapseed, Glaze, Stackables, Fragment).

will quickly take two photos, at a light and dark exposure, and then combine the two images. Any movement between the first and second exposure will result in blurry images.

Once the images are combined, you can view and save the blended image with different presets. HDR Natural is always shown first. Swipe left to see the image with differ-

ent presets, and if you like the image, tap to select. You can select multiple presets, which will be saved as individual image files to your camera roll when you tap Save.

# 20. Choosing an Editing App

Y ou've taken a well composed and exposed photograph, and now time to have some fun with post-processing! You can alter your photographs using editing apps, which allow you to make a range of basic adjustments—from brightness, contrast, and saturation refinements to artistic effects that transform your photograph into a unique piece of art.

▼ *Modern Boy* (apps: ProCamera, Image Blender, Superimpose, iColorama, Snapseed).

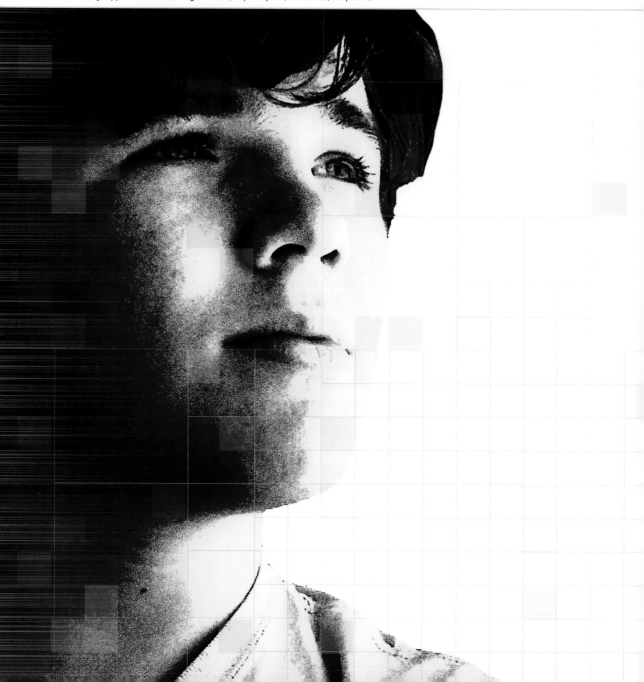

## Important App Features

There are so many editing apps out there for your iPhone, it can be hard to know where to begin. As a starting point, this book shares the apps I use in the next few sections and the tables in the Basic Editing Apps and Recommended Creative Apps sections. As you experiment with editing apps, it's important to realize that not every editing app is created equally.

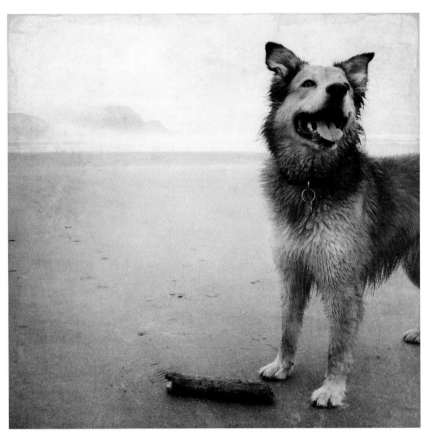

▲ *Fetch?* (apps: ProCamera, Stackables).

The best editing apps will have the following features:

**1. Full Resolution Output.** You want the images you save from an app to have the same resolution as the starting image files you load into the app. Some apps downsize the files they output.

**2. Adjustable Effects.** You want an opacity or intensity adjustment available when you apply an effect, to moderate the result.

**3. Progressive Editing.** You want to apply multiple effects to the same photograph in the same session within an app, rather than having to save and reload the image.

**4. Undo Last Step.** When you apply multiple effects within the same session, you want to be able to undo the last step. It is easier to experiment when you can try different options without worry that you are going to lose a good image by going one step too far in the processing.

There are workarounds I'll share if an editing app doesn't have these features, but editing is simpler if you don't have to take extra steps.

> "It is easier to experiment when you can try different options without worry that you are going to lose a good image."

# 21. Monitoring the Resolution

There is a sneaky thing that can happen as you edit with apps. While you've made the effort to set your camera app to get the maximum resolution and the best image quality in your captures, post-processing apps may reduce the resolution without your knowledge. Some apps have a specified output resolution, while other apps limit your image output resolution based on your device's native camera resolution.

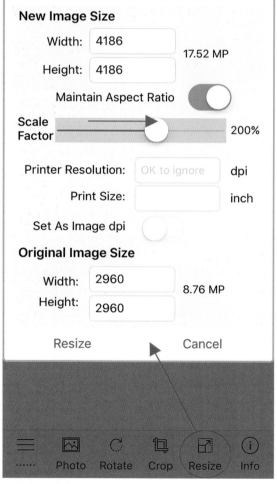

▲ Resize in Big Photo.

> "If tack-sharp details are important to your work, any upsizing should be kept to a minimum and carefully evaluated on a larger screen."

## What to Watch For

To learn how an app affects resolution, there are a couple of things to look for. Look for quality options when you save a file, or go into the app settings and look for options to set the output file type, size, or resolution. If there are settings available, always select the highest quality option and, where possible, use TIFF or PNG file types. If you don't see any options within an app, you will need to check the output resolution independently.

## Big Photo App

I use the Big Photo app to check and, if necessary, increase the resolution of image files. Open Big Photo and load the image you want to check. Tap the Info icon, and the file information is shown.

If the pixel dimensions are the same as your starting image file, then you know the app you used does not reduce resolution; you can continue processing without resizing.

## Boosting Resolution

If the pixel dimensions are less than your starting image file, you can increase the resolution using Big Photo's Resize function. Tap

Resize, set the Maintain Aspect Ratio switch to "on," and then use the Scale Factor slider to increase the resolution.

I typically increase the image size to no more than 300 percent of the original file, up to about 4000 pixels/side. This size range gives me flexibility for printing, without causing obvious artifacts from the resizing in the image file. Some degradation in sharpness or quality can occur with this upsizing process—but since I'm often intentionally degrading the sharpness in my processing, I don't get too concerned about that. If tack-sharp details are important to your work, any upsizing should be kept to a minimum and carefully evaluated on a larger screen.

▼ *Replicate* (apps: ProCamera, Snapseed, Image Blender, Decim8, iColorama, Stackables).

# 22. App Operation

Every editing app available for the iPhone is different in its options and operation. I enjoy this aspect of mobile photography, which involves continually exploring new apps, learning the interface, understanding the strengths of the app, and then combining it with other apps in creative ways.

Even though there are no standards of operation, there are some general rules of thumb you can use to help you quickly get oriented within a new app.

## Permissions

When a photography app first opens, it will ask for permission to access the Camera Roll and the camera. Always answer "yes." If you accidentally answer "no," you can change the permissions in your iPhone Settings under Privacy.

## Opening or Saving a File

The icons for opening a file or saving a file will often be in one of the four corners of the screen. Look for one of the possible Open File icons or Export File icons.

In most iPhone apps, there are many options for exporting a file from the app. Normally, you will want to save the file, so look for one of the terms that indicates you are exporting to the main image file folder on your iPhone, called the Camera Roll, Gallery, Photo Library, or Album.

For best results, save your altered images as a new file. Some apps provide the option to save non-destructive edits to the original file using a sidecar file, but this feature is not recommended. The sidecar file is not supported by all apps you might want to use to open your edited files.

## Settings, Info, and Adjustment

For more information, settings or adjustments in the app, look for the menu or slider icons and explore the functionality.

## Zoom and Pan

Many apps allow you to magnify your work (zoom) and move it around on the screen (pan) by using two fingers on the image. Spread your fingers apart to increase magnification, pinch your fingers together to decrease magnification, and drag them together in the same direction to pan.

▲ Export icons.

▲ Open icons.

▲ Menu icons.

▲ Settings icon.　　　　▲ Info icon.

▲ What Lies Beneath (apps: ProCamera, iColorama, Snapseed, Mextures, Repix, Image Blender).

# 23. App Organization

As you add apps, it's easy for your camera and photography apps to get lost in the midst of everything else on your iPhone. It's helpful to group your camera and photography apps so that you can find them quickly and easily.

## Quick Access Bar

On my iPhone, my favorite camera apps are on the quick access bar along the bottom row, so no matter which page my iPhone opens on, I have the camera apps available. Using Touch ID to unlock the iPhone, the ability to take a photograph in any of these apps is only one tap away.

## Editing Apps Folders

I group my editing apps into folders by frequency of use. My most used apps are in one folder, and other apps are in backup folders. The order of apps within the folders is important for quick access, as well. Your frequently used apps should be grouped together on the first page of the folder. If there is an app I want to try to use more in my editing workflow, I will move it to the first page in a folder to make sure I see it.

## Group for Efficiency

On my iPad, I use folder groupings by type of app, and my folders for editing apps are

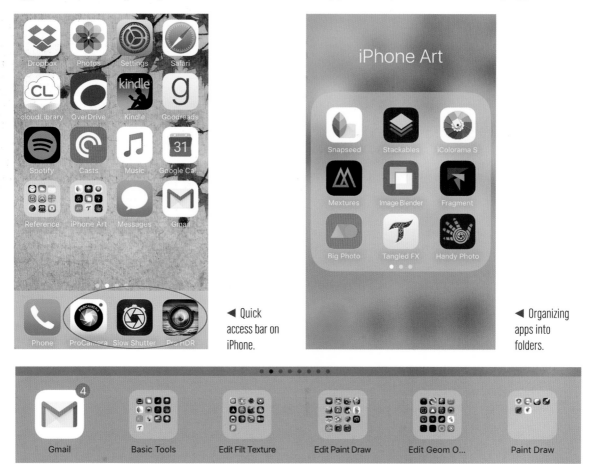

◄ Quick access bar on iPhone.

◄ Organizing apps into folders.

▲ Quick Access Bar on iPad.

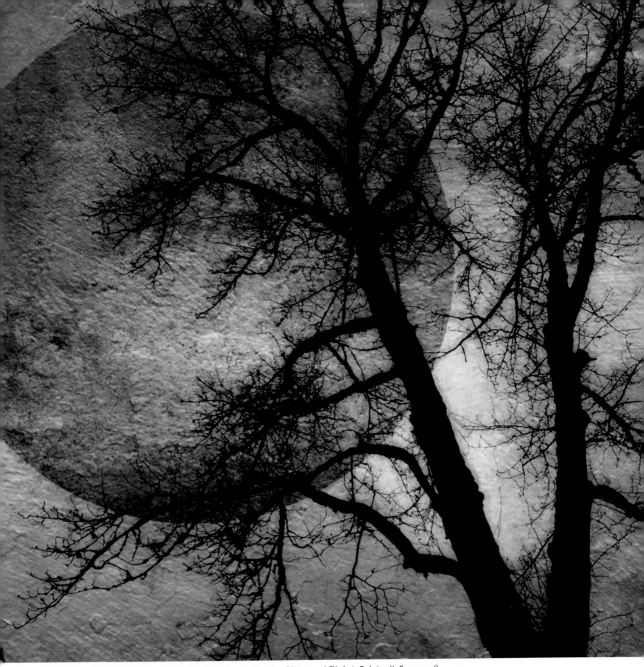

▲ *Luminous* (apps: ProCamera, Pixlr, Afterlight, Image Blender, Distressed FX, AutoPainter II, Snapseed).

along the quick access bar on the bottom (rather than camera apps), since I primarily use this device for editing.

Consider how you use your apps, then find ways to group them together so you can access them efficiently. There is no correct answer for app organization, and you may need to experiment with different categories before you settle on an organization system that works well for you.

# 24. Basic Global Adjustments

The process to edit photographs starts with making basic global adjustments—things like brightness, contrast, and saturation. My favorite app for global adjustments is Snapseed, which is free, easy to use, and provides excellent performance.

## Snapseed Editing Basics

Once you have opened your photo in Snapseed, you will be on the Home screen. To access the editing options, tap the Menu icon. From the Tools menu, access the global adjustments by tapping the Tune Image option.

Within each Snapseed editing option, you can access a menu of adjustment options by tapping the Slider icon on the bottom bar, or scrolling up and down on the image. As you move your finger up or down on the menu, you move through the options and they will be highlighted blue in turn. To select, lift your finger when the desired option is highlighted blue.

To make the adjustments, slide your finger right to increase or left to decrease. The information at the top of the screen shows your current selection and how much it has been adjusted. A zero reading indicates the starting point of the image when the menu was opened. Don't be afraid to push the settings to extremes to see what they do.

## Finish and Save

When you are finished with your global adjustments, return to the Home screen by tap-

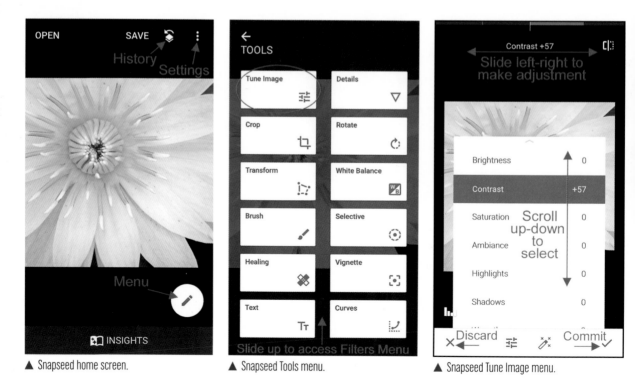

▲ Snapseed home screen.  ▲ Snapseed Tools menu.  ▲ Snapseed Tune Image menu.

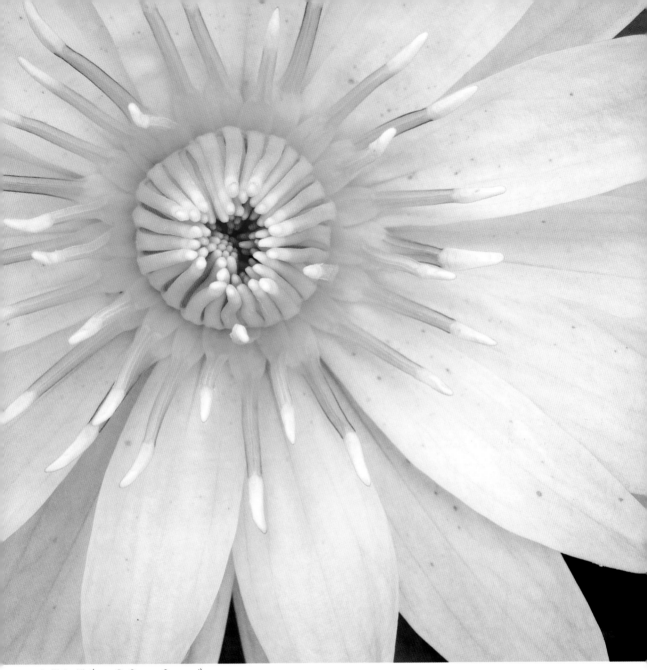

▲ Water Lily (apps: ProCamera, Snapseed).

ping either the Discard icon (to exit without making changes) or the Commit icon (to exit with the changes applied). It is important to note that your changes are not automatically saved when you return to the home screen. You must go to the Save menu and save your new version to the Camera Roll. Select "Export" to save an altered copy to the camera roll. You can change your desired export file type in the Settings menu.

"Don't be afraid to push the settings to extremes to see what they do."

# 25. Selective Adjustments

While global adjustments are quick and easy, there are times when you need to target an adjustment to a specific area of the photograph. Snapseed's Selective editing tool allows you to adjust the brightness, contrast, saturation, and structure in a targeted area.

## Marker and Range Adjustment

From the Tools menu, open the Selective option. Tap the Add Marker icon and place the marker on the image. The marker will be highlighted blue, indicating it is the active marker for adjustments. If you tap on the selected marker, you will get a popup menu and you can drag the marker to a precise location using a magnifying glass window. The spot adjustment will be done only on similar pixels, so you want the placement to be specific.

Once you have placed the marker, select the range of adjustment by pinching or spreading two fingers on the screen. You will see some pixels switch to red; these indicate the pixels affected by this marker.

## Adjustments

Moving your finger away from the active marker, swipe up and down on the screen to select the type of adjustment you want to make. When your option is selected, swipe left or right to make the adjustment. (Note: If you swipe on the active marker, you will move the marker.)

You can adjust each setting independently for a marker. You can also add or copy multiple markers if you have more than one spot you want to adjust. Tap any marker to make it the active marker for adjustments. To see the results of your changes, tap the Compare to Original icon.

## Discard or Commit

Once you exit, using either Discard or Commit, your specific adjustment points are lost. When you re-enter the menu for further adjustments, you will need to place new markers and start the process again.

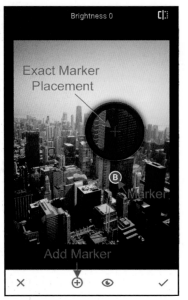

▲ Placing a marker.

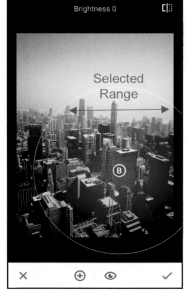

▲ Selecting the range.

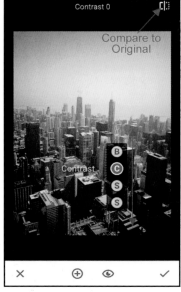

▲ Selecting adjustment type.

▲ *Chicago Skyline* (apps: ProCamera, Snapseed).

Even when you've done your best to reduce distractions at the time you are taking your photograph, some elements cannot be eliminated. In these cases, you can remove distractions after the fact by retouching or cloning in post-processing.

## Removing Distractions

In Handy Photo, move through the menu options by dragging and rotating the ring around the Main Menu icon (upper right corner).

For quick distraction removal, use Handy Photo's retouch function. Tap Retouch on the main menu, and a new menu appears in the bottom left corner. Select the Brush icon and use your finger to paint over the problem area. Painted areas are highlighted red. Tap the Erase icon to erase portions of the painted area—or tap the Undo icon to eliminate the last selection you painted. To paint a detailed selection, adjust down to a smaller brush size and zoom in on a small area.

## Retouch and Content-Aware Fill

When you have finished painting the area you want to retouch, tap the screen. Handy

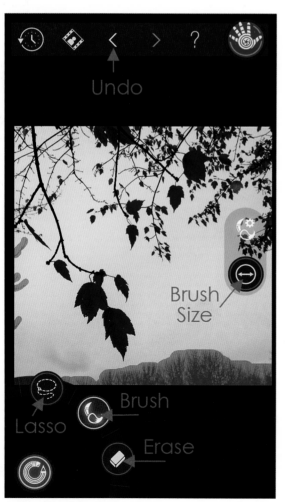

▲ Handy Photo Retouch menu.

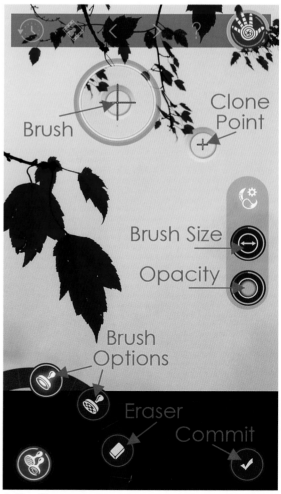

▲ Clone Stamp menu.

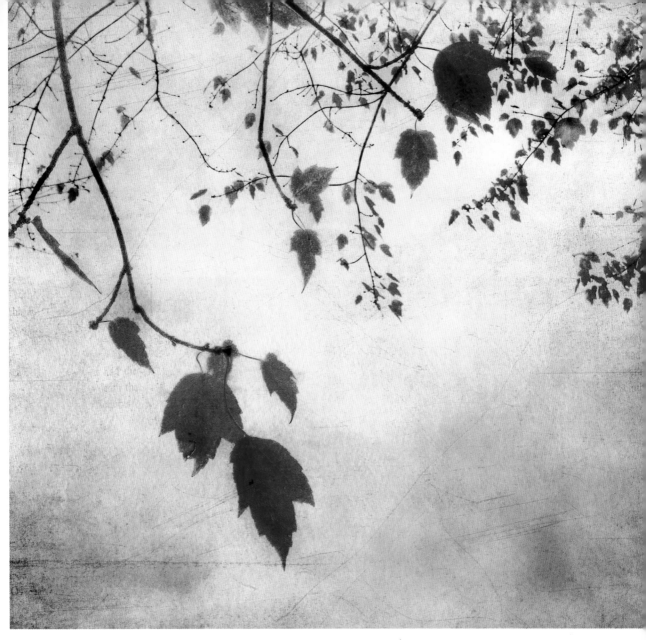

Photo will then apply a content-aware fill, replacing the pixels inside the painted area with pixels from just around it. This function works best for elements surrounded by a consistent background. If you don't like the result, undo the retouch and start again, or repeat in different areas of the image.

When complete, tap the Commit icon in the lower right to apply the changes and return to the main menu. From there, be sure to save your image to the Gallery.

▲ *Defying Gravity* (ProCamera, Handy Photo, Distressed FX, AutoPainter, AutoPainter II, XnView Photo FX, Image Blender).

## Clone Stamp

If Retouch doesn't work, you can use the Clone Stamp function to directly copy pixels from one part of the image to another. Tap on the photo to set a clone point (selecting the "good" pixels you want to copy over the "bad" area) and then paint with the brush in the area where you want to replace the pixels.

# 27. Basic Editing Apps

This group of editing apps (facing page) provides the basic functionality an experienced digital photographer would expect to have available for editing photographs. No single app provides all of the desired functionality, so you must pick and choose based on your needs. All of these apps are universal apps, which run on both iPhone and iPad, and have been supported by the developer through multiple iOS revisions.

▼ *She Opens Her Own Doors* (apps: ProCamera, Image Blender, Stackables, Superimpose, Mextures, Snapseed).

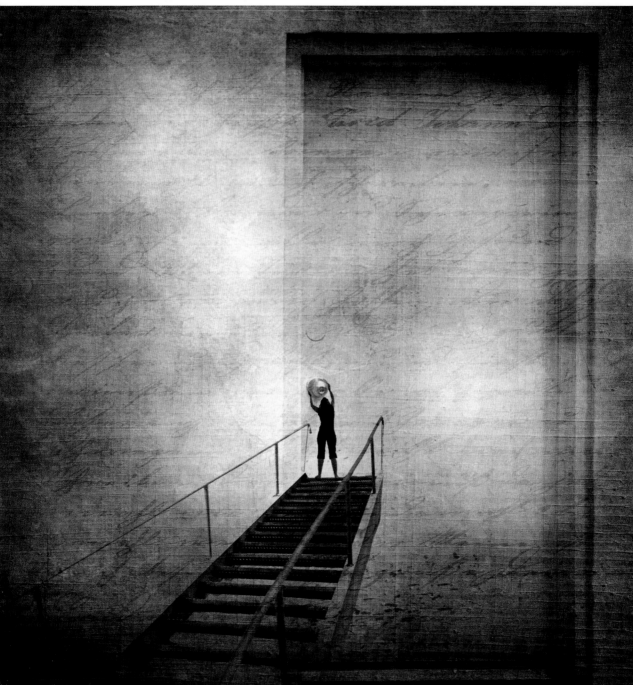

| App Name | Snapseed | Handy Photo | Enlight | Photoshop Fix |
|---|---|---|---|---|
| App Developer | Google, Inc. | Adva-Soft | Lightricks, Ltd. | Adobe |
| **Global Adjustments** | | | | |
| Brightness | ● | ● | ● | ● |
| Contrast | ● | ● | ● | ● |
| Saturation | ● | ● | ● | ● |
| Ambience/Vibrance/Clarity | ● | | | |
| Shadows | ● | ● | ● | ● |
| Highlights | ● | ● | ● | ● |
| Temperature/Tint | ● | ● | ● | ● |
| White Balance | ● | | ● | |
| Split Tone | | | ● | |
| Curves | ● | | ● | |
| Structure | ● | | ● | ● |
| Sharpen | ● | ● | ● | ● |
| Noise Reduction | | | ● | |
| **Spot Adjustments** | | | | |
| Brightness | ● | ● | ● | ● |
| Contrast | ● | ● | ● | ● |
| Saturation | ● | ● | ● | ● |
| Structure/Sharpen | ● | ● | | ● |
| Portrait Enhancements | ● | | | ● |
| **Crop** | | | | |
| Free | ● | ● | ● | ● |
| Standard Aspect Ratios | ● | ● | ● | ● |
| Uncrop (Expand Frame) | ● | ● | | |
| **Rotate/Transform** | | | | |
| Straighten | ● | | ● | ● |
| 90 Degree | ● | ● | ● | ● |
| Flip Vertical or Horizontal | ● | ● | ● | ● |
| Transform Perspective | ● | | ● | |
| **Fix** | | | | |
| Clone | | ● | ● | ● |
| Heal/Retouch (Content Aware Fill) | ● | ● | ● | ● |
| Move/Refit | | ● | ● | ● |
| **Features** | | | | |
| Multiple Adjustments (Within Session) | ● | ● | ● | ● |
| Undo Last Step/History | ● | ● | ● | ● |
| Save Lossless File Types (.TIF, .PNG) | ● | ● | ● | |

# 28. Color Filters

Paired with the right photographic content, a simple shift in color tones can evoke drama or nostalgia, celebratory joy or poignant sadness. When you adjust the color tones, you adjust the emotional tone of the photograph. Color also begins to determine whether your photograph stays grounded in the real world or begins to move into the realm of the abstract. Color filters are the most widely available alteration within iPhone photo editing apps.

## Color Beyond the Expected

For much of my artwork, the starting point is to alter color beyond the expected photographic tones. Mextures is a great app for making these kinds of dramatic color shifts, with a wide variety of colors and adjustments available.

For altering color, use the Radiance menu. Once you are in the Radiance menu, tap a filter to apply it. Within this menu, you can quickly rotate the filter or change its opacity. The rotation is an especially nice feature in this app, which allows you to customize the filter application for each photograph.

For further refinement of your filter, you can change the blend mode or make other photographic adjustments. Tap the Blend

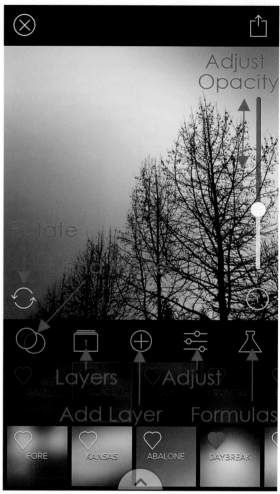

▲ Mextures Radiance menu.

Mode icon to explore those options. Take time to experiment here. Changing the blend mode alters how the colors are applied to the photograph, giving an even wider range of options for each color filter.

## Layers

Once you like the settings for the current filter, you can add another layer and start again, altering the color further or adding

> "For much of my artwork, the starting point is to alter color beyond the expected photographic tones."

▲ *It's Not So Complex* (apps: ProCamera, Mextures, iColorama, Image Blender).

other effects. As you add layers, you can go back and adjust any previous layer. Tap the Layers icon to see the list of layers currently applied. Tap a layer to select it and then tap the Exit icon to edit or tap the Delete Layer icon to delete.

When working with color filters, apply the filters before you make basic global adjustments to your photograph. The filters often impact the brightness and contrast along with color, so any global adjustments made prior to the filter application may be wasted effort.

▲ Noir Photo app.

▲ Snapseed Black & White menu.

Without the impact of full color to attract or distract the viewer, monochromatic images turn the focus to the lines and tones in the photograph. Since photographic history is rooted in monochromatic images, these filters are widely available in iPhone apps. Apps with monochromatic filters create effects that range from faded sepia to dramatic film noir looks.

## Noir Photo

One of my favorite apps for quickly achieving a dramatic black & white photograph is Noir Photo. Once you open an image in Noir Photo, tapping any of the presets both converts the photograph to a toned black & white image and applies a highlighting effect. To move and resize the highlight area, tap the image and an ellipse appears. Using one

finger, you can adjust the position of the ellipse. With two fingers, you can tilt, increase or decrease the size of the ellipse.

You can also fine-tune the film noir effect by using the Outer Brightness, Inner Brightness, and Contrast dials along the bottom. Use the Color Tone icons to switch the color of the monochromatic effect between sepia, grey, blue, and green.

## Snapseed Black & White

Snapseed also provides a basic black & white conversion with a nice range of adjustability. From the Filters menu, select the Black & White option and begin adjusting your brightness, contrast, or grain. You can also select Color Filter to help separate the tones in the black & white conversion based on the original colors captured in the photograph.

To create a custom look, save your black & white conversion and then apply a color filter, such as Snapseed's Vintage effects. Since the color filters shift the highlight and shadow tones, regardless of whether the starting image is in color or black & white, you end up with a uniquely toned monochromatic image.

▼ *The Last Tree* (apps: ProCamera, Noir Photo, Big Photo).

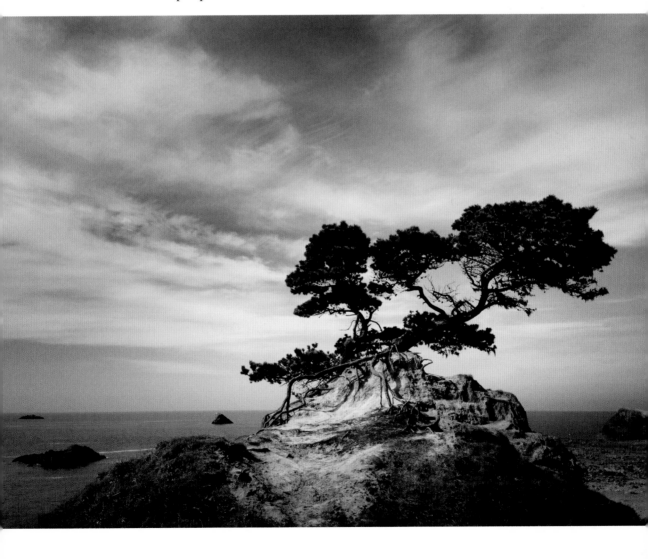

# 30. Texture and Grunge Effects

A texture is a separate image file that you apply to your photo, with effects ranging from subtle grain variations, to canvas weaves, or crackling paint. Grunge effects take textures to the extreme, with distressed effects providing dramatic variations—think scratches, water marks, scuffs, folds, or other damage. Many apps include options for applying texture and grunge effects along with color filters.

## Starting with Stackables

My favorite app for adding texture is Stackables, which has a wide range of textures and options to control their application. After loading a photo, Stackables starts by adding a texture layer. Scroll through the texture options on the right side, tapping different textures to see the effect on your image.

## Refining the Look

For any texture, you can make adjustments by rotating the orientation, changing the blend mode, and adjusting the opacity. Tap the current blend mode to select options other than the default mode of Overlay. The opacity slider on the bottom allows you to

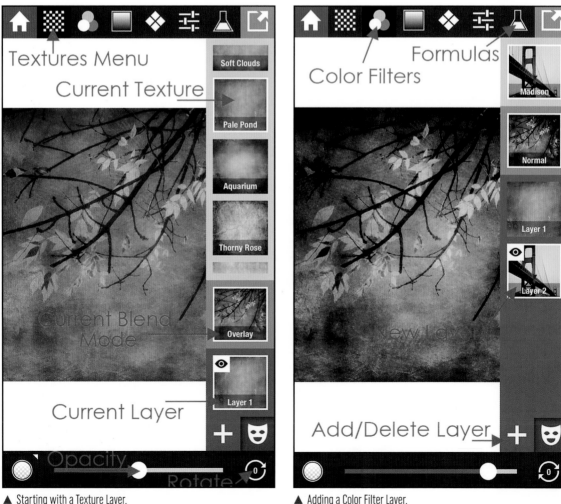

▲ Starting with a Texture Layer.  ▲ Adding a Color Filter Layer.

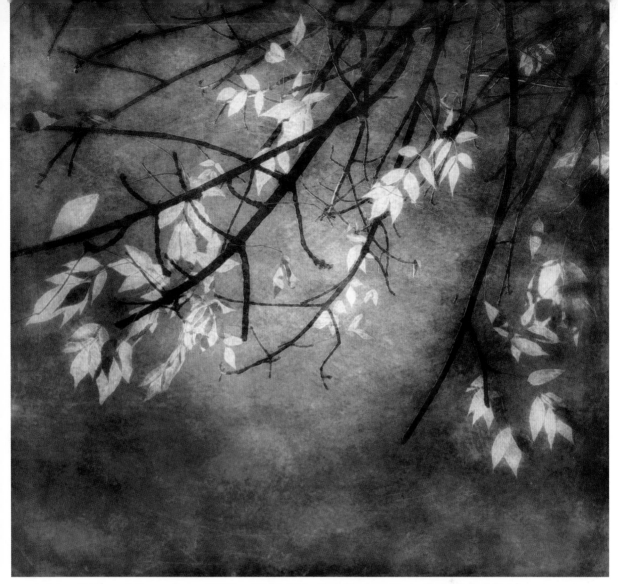

▲ *Autumn Light* (apps: ProCamera, Snapseed, Distressed FX, AutoPainter, Stackables, Image Blender, Tangled FX, Handy Photo).

control the intensity of the blend. (More on blend modes in later sections.)

## Multiple Layers

Stackables allows you to add multiple layers with different types of effects. Simply tap the Add Layer icon and a new layer is added. You can change the layer type, making independent selections and adjustments for each layer. Stackables has many layer types beyond textures, including color filters, gradients, patterns, and global adjustments.

## Formulas

Stackables also has Formulas, a great starting point for editing. Tap the Formulas icon and then tap any Formula to preview it on your photograph. Once you find a Formula you like, tap the wrench icon (lower right) to apply the Formula. You can edit, add, or delete layers in the Formula to further customize your results. If you create an effect you like, you can save it as your own Formula to reuse in the future.

# 31. Painterly Effects

▲ Glaze main menu.

▲ Selecting effects in Waterlogue.

With all of these amazing editing apps at your fingertips, you can completely transform a photograph using artistic effects, so that it no longer looks photographic. I use painterly effects when I'm trying to soften the edges in an image, add variations in color and texture, or take the image a step away from realism. There are apps which approximate most painting mediums, across the range of oil, acrylic, watercolor, and pastel.

## Glaze App

The Glaze App applies painterly effects which give the impression of oil or acrylic painting. You apply an effect to your chosen photo by scrolling along the bottom and tapping an option. The app will take a few moments to apply the effect. You can try other effects, switching back and forth between your last few selected options to compare results quickly.

When you are ready to save, one of the great things about Glaze is that you can save an image at a higher resolution than the original photograph. I always save with the largest output resolution, which is 4096 pixels on the long side.

## Waterlogue App

For watercolor effects, Waterlogue is quick and easy. When you open the app and load a photo, the app automatically applies the Natural effect. To change the effect, scroll along the bottom and tap an alternate option. A small window over your image will pop up with a preview. If you like how it looks, tap the preview window to apply the new effect.

For more adjustments, continue to scroll over to the right in the menu. You can change the size of the output (choose Giant), the intensity (lightness/darkness), and whether you have a border or not. Unlike Glaze, Waterlogue does not save files at starting image resolution—even if you select the highest resolution option.

▼ *Lily Pond* (apps: ProCamera, Handy Photo, XnView Photo FX, Decim8, Glaze, AutoPainter II, Repix, Image Blender).

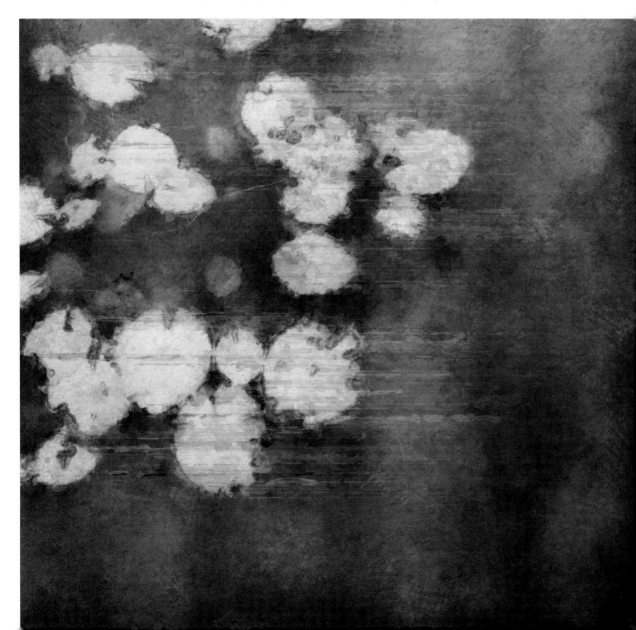

# 32. Illustration Effects

Illustration effects work well to bring contrast and definition or highlights to the edges of objects in your image. Illustration apps will convert your photograph to anything from cartoons and pop art to sketches and brushstroke outlines.

## Tangled FX App

For a wide range of illustration styles, I turn to Tangled FX, which has both light and dark outline effects, fine tuning controls, and high resolution output (4096 pixels maximum). I especially like the effects that create a light outline, giving the edges a glowing highlight. After loading a photo into Tangled FX, explore the options by tapping the different effects along the bottom of the screen. The app will quickly show you the effect in preview mode.

## Fine Tune

When you find an effect you like, you can use the Fine Tune menu to make additional adjustments. Tap to open the menu, scroll up and down to see the available controls, then use the slider bars to make changes.

▲ Tangled FX home screen.

▲ Tangled FX fine tune menu.

▲ *The Color of Shade* (ProCamera, Distressed FX, Tangled FX, Waterlogue, Image Blender).

To see the image as you make the adjustments, use the One Line View option. This makes the controls visible one at a time along the bottom so you can make your adjustments while seeing the impact on the image. Scroll up and down to move through the adjustment options, and tap to close the menu when you are done.

## Full Resolution

When you are ready to save, change to full resolution by tapping on the Current Resolution setting. Tangled FX will reprocess the image at full resolution, which takes quite a bit longer, and then you can save it to the Camera Roll. If the highest resolution is not showing when you tap the Current Resolution icon, go into the Settings menu and increase the Full Size Resolution setting.

# 33. Digital Effects

Approximating traditional mediums is interesting, but the real fun happens when you embrace the unique capabilities of a digital medium. Digital effect apps add geometric elements to your photograph, create glitches reminiscent of a failing computer, or distort an image by warping, stretching, or deforming.

## Fragment App

The Fragment app has a unique approach to adding geometric shapes to your image. You select from a range of simple and complex shapes, called fragments, which are filled with an altered version of your image and applied over the original photograph. Using the randomize button allows you to explore many options quickly.

The app gives you control of the location, angle, and magnification of both the fragment and the photograph filling the fragment. The Quick Change icons enable quick adjustment of either the fragment or the fill, depending on which is selected. You can also use two fingers, rotating and pinching, to make similar changes. Tap the Adjustments

▲ Fragment main menu.

▲ Decim8 main menu.

▲ *Cause and Effect* (apps: ProCamera, Snapseed, Decim8, Fragment).

icon at the bottom of the screen to adjust the brightness, contrast, saturation, blur, color tone, and more for the fragment.

## Decim8 App

My favorite app for glitch effects is Decim8. Start by tapping the Random FX icon to have Decim8 apply two randomly chosen effects. If you like the result, you can explore more variation within these effects by tapping the Random Params icon. If you don't like these results, you can either use Random FX again to randomly select new effects, or go into the Effects menu and turn individual effects on and off.

The more effects you apply, the stronger the abstraction. If you like a combination of effects, you can save them as your own preset for future use. Decim8 does not produce the same result each time you process an image with a given effect, so save anytime you see an effect you like.

Another advantage of working in a digital medium is the ease of adding other imagery to a photograph. This can be done by cutting elements from another photograph (covered in a later section), or through apps which provide imagery, already cut, prepared and ready to add.

## Alien Sky

Moons and stars feature regularly in my images, but you can't capture these kinds of images with an iPhone. The Alien Sky app is my favorite source of space-themed elements,

with a broad range of stars, planets, moons, and other space features, real and imagined.

The first step in Alien Sky is to select an effect. Swipe left and right to see the options in the current category, or select the menu to switch category. Once you select an element, use two fingers to move, scale, and place it in the correct location. Use the Edit menu to blend it with your photo by adjusting the brightness, opacity, blur, saturation, color, or other options using the slider bars. Each element has different adjustments available for blending. Use the mask feature

▲ Adding an Element.

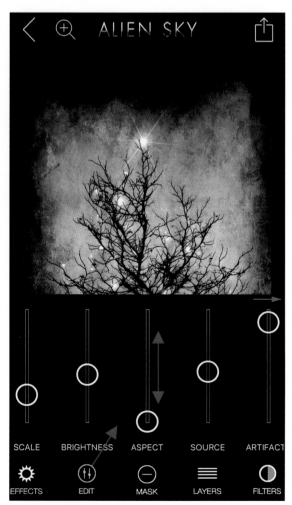

▲ Editing the Element.

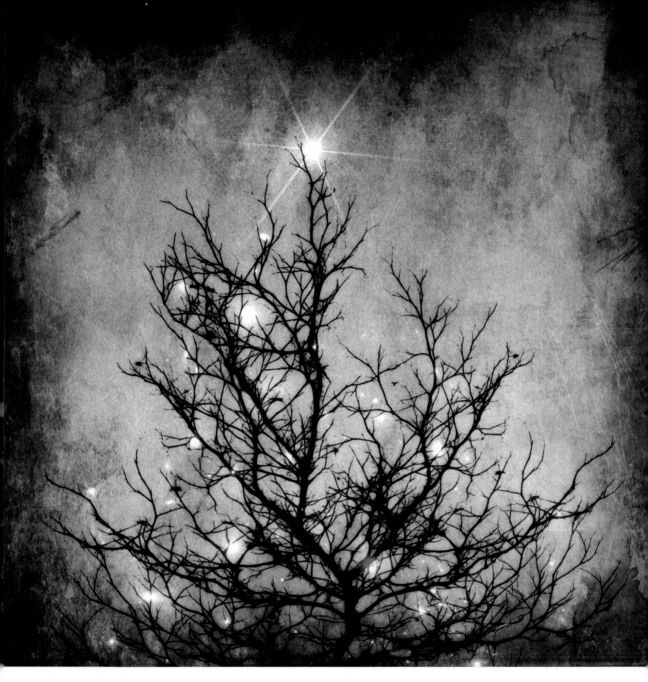

▲ *Wish Gathering* (apps: ProCamera, Snapseed, TangledFX, Image Blender, Classic Vintage Photo, Alien Sky, Stackables).

to erase the element in areas you want it to appear behind objects in your photograph. To add more effects to the same image, you can add additional layers through the Layers menu.

## Subtle or Outrageous?

When adding elements, you can be subtle or outrageous. Another similar app, LensFX Epic Photo Effects, includes explosions, dinosaurs, spaceships, robots, helicopters, and more. Experiment with these apps to see if you enjoy this aspect of altering reality.

One of the last things I do when editing an image is add an edge effect, which can serve to further define the edge of the frame, point the viewer's eye toward a focal point, and reduce distractions that come with high-contrast elements intersecting the edge of the frame. Edge effects such as vignettes or borders are available in many apps.

## Snapseed's Lens Blur

Snapseed has a great Vignette tool for darkening the edges, but you can get both vignette and blur using the Lens Blur option under the Filters menu. Start by choosing between linear or elliptical blur. Move the focal point by tapping on the image and moving the blue dot. Set the untouched area of the edge effect by using two fingers, pinching your fingers to bring the edge effect closer to the focal point or spreading your fingers to move it away. In the Fine Tune menu, adjust the blur and vignette strength for the edge effect, as well as the width of transition from center to edge.

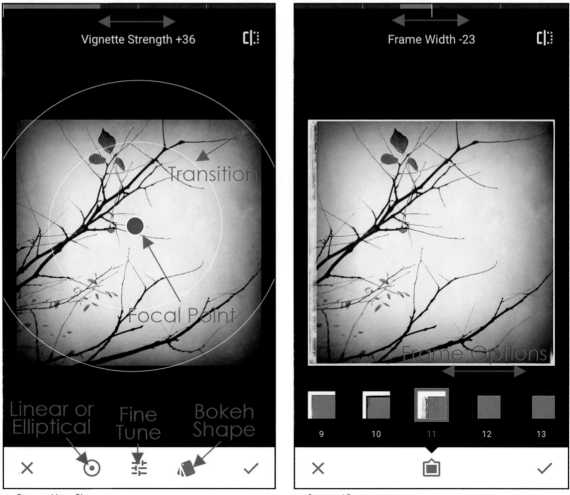

▲ Snapseed Lens Blur menu.　　　　▲ Snapseed Frames menu.

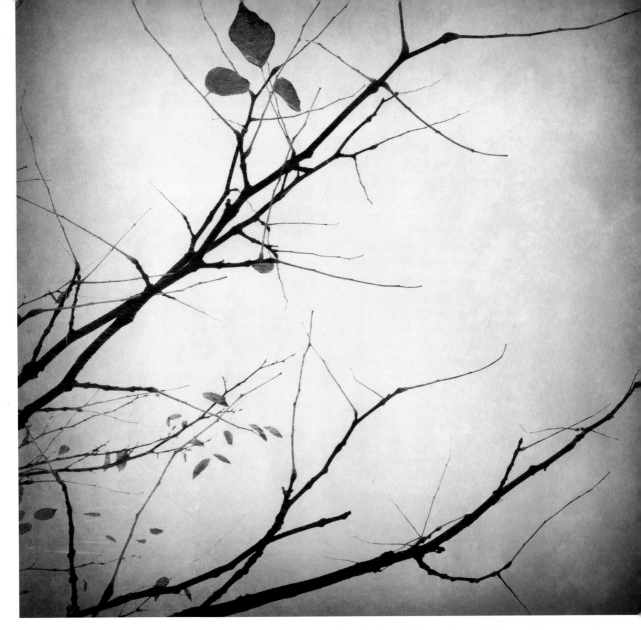

## Borders

Borders are a more dramatic visual clarification of the edge of a photograph than a vignette, often providing a finished look for the frame. Borders can provide a structured edge, ranging from a simple black stroke to effects that approximate different types of traditional photographic borders, such as instant film. Snapseed's Frames menu makes it quick and easy to add a graphic or photorealistic border. Scroll through the menu for both light

▲ *Lingering* (apps: ProCamera, Snapseed, Distressed FX, XnView Photo FX).

and dark border options and then adjust the frame width for your image.

One quick note: Opaque borders might look great when viewed online, because they provide a physical-looking edge, but this doesn't always translate well to printed presentations. It's always a good idea to save a version without the border as an option to use later, if desired.

# 36. Full-Featured Apps

▲ iColorama main menu.

▲ iColorama sub-menu.

It's fun to experiment with apps and effects, but it can be overwhelming to learn so many different interfaces. A good place to start is with a full-featured app, which allows you to do much of your editing within a single interface and session. These apps incorporate basic adjustments, color filters, textures, artistic effects, borders, and more—providing significant creative flexibility for a single investment of time and money.

## iColorama App

Many of the apps covered in the previous sections are full-featured apps, from which I've highlighted a single feature or effect. Another fantastic full-featured app is iColorama.

Load your image and select an effect menu by tapping Select on the top menu bar. Once you have selected an effect menu, you scroll through the options along the top to select a sub-menu. Within the sub-menu, there are

additional selections in the form of Presets. Tap the Preset icon and another set of options will appear. Scroll the list of presets, up and down, and tap any of the entries to preview the image. When you find an effect you like, tap the Preset icon again to make the menu disappear.

Once you've selected your effect, you have more adjustment flexibility. Opacity and other setting adjustments that are available for the selected preset show up along the bottom. Reducing opacity is a great way to subdue the look of a chosen effect. You can also selectively apply the preset using a mask. Tap the Show/Hide Mask Menu icon to open or close the Mask menu. Once you've made all of your adjustments, tap the Apply icon on the top menu bar to process the image.

You can apply multiple effects in sequence and iColorama provides a history feature, which allows you to see and revert to any of the steps you've made in your edit.

▼ *Along Those Lines* (apps: ProCamera, iColorama, Image Blender).

# 37. Recommended Creative Apps

| App Name | App Developer | EFFECTS | | | | | |
|---|---|---|---|---|---|---|---|
| | | Basic Adjustments | Color Filters | Monochromatic Filters | Texture and Grunge | Painterly | Drawing, Illustration |
| Afterlight | Afterlight Collective | ● | ● | ● | ● | | |
| AlienSky | BrainFeverMedia | ● | ● | ● | ● | | |
| Aquarella | JixiPix Software | | | | | ● | |
| Arista Impresso | JixiPix Software | | | | | ● | |
| Big Lens | Reallusion | | ● | ● | | | |
| Brushstroke | Code Organa | | | | | ● | |
| Circular Tiny Planet Editor | BrainFeverMedia | | ● | ● | ● | | |
| Decim8 | Kris Collins | | | | | | |
| Distressed FX | We Are Here | | ● | ● | ● | | |
| Dramatic Black & White | JixiPix Software | | | ● | | | |
| Enlight | Lightricks, Ltd. | ● | ● | ● | ● | ● | ● |
| Fragment | Pixite | | | | | ● | |
| Glaze | Gilles Dezeustre | | | | | ● | |
| Grungetastic | JixiPix Software | | | | ● | | |
| Handy Photo | Adva-Soft | ● | ● | ● | ● | | |
| iColorama | Katerina Alieksieienko | ● | ● | ● | ● | ● | ● |
| iCPainter | Katerina Alieksieienko | | | | | ● | |
| LensFX Epic Photo Effects | BrainFeverMedia | ● | ● | ● | ● | | |
| Mextures | Merek Davis Com | ● | ● | ● | ● | | |
| Noir Photo | Moment Park | | | ● | | | |
| Pixlr | Autodesk | ● | ● | ● | ● | ● | ● |
| Reflect | BrainFeverMedia | | ● | ● | | | |
| Repix | Sumoing | ● | ● | ● | ● | ● | ● |
| Snapseed | Google | ● | ● | ● | ● | | |
| Stackables | Samer Azzam | ● | ● | ● | ● | ● | |
| Tangent | Pixite | | | | | | |
| Tangled FX | Orange Qube | | | | | ● | ● |
| ToonCamera | Code Organa | | | | | | ● |
| Vintage Scene | JixiPix Software | | | ● | ● | | |
| VSCO Cam | Visual Supply Company | ● | ● | ● | | | |
| Waterlogue | Tinrocket | | | | | ● | |

▼ This list provides details on the effects and features available in the creative photo editing apps I use most frequently. These apps typically have unique effects or features compared to other similar apps, and have been supported by the developer through multiple iOS revisions.

Unless otherwise noted, these apps are universal (run on both iPhone and iPad) and export full resolution JPG files. Some apps offer in-app purchase of additional effects or features.

| Digital (Geometric, Glitch, Distort) | Blur | Vignette | Borders/Frames | Added Elements | BLEND Multiple Image Blending | FEATURES Randomize Effect | Adjustable Filters/Effects | Multiple Effects Within Session | Undo Last Step/History | Notes |
|---|---|---|---|---|---|---|---|---|---|---|
| | | ● | ● | | ● | | ● | ● | ● | |
| | | ● | | ● | | | ● | ● | | 2, 4 |
| | | | | | | ● | ● | | ● | 1, 3 |
| | | | | | | ● | ● | | ● | 3 |
| | ● | | | | | | ● | ● | ● | |
| | | | | | | | ● | | ● | 4 |
| ● | | | | ● | | | ● | ● | | 2, 4 |
| ● | | | | | | ● | ● | | | |
| | | | | ● | | | ● | ● | | |
| | | ● | | | | ● | ● | | ● | 1 |
| ● | ● | ● | ● | ● | ● | | ● | ● | ● | 4 |
| | | | | | | ● | ● | ● | | |
| | | | | | | ● | | ● | | 2 |
| | | | | | | ● | ● | | ● | 1, 3 |
| | | ● | ● | | | | ● | ● | ● | 4 |
| ● | ● | ● | | | ● | | ● | ● | ● | 1, 4 |
| | | | | | | | ● | | | |
| | | | | ● | | | ● | ● | | 2, 4 |
| | | | | | | | ● | ● | ● | |
| | | | | | | | ● | | | |
| | ● | ● | ● | ● | ● | | ● | ● | ● | |
| ● | | ● | | ● | | | ● | | | 2, 4 |
| | ● | | ● | ● | | | ● | ● | ● | |
| | ● | ● | ● | | ● | | ● | ● | ● | 4 |
| ● | ● | ● | | | | | ● | ● | ● | 4 |
| ● | | | | ● | | | ● | ● | ● | |
| | | | | | | | ● | | | 2 |
| | | | | | | | ● | | | |
| | | ● | ● | | | ● | ● | | ● | 1, 3 |
| | | ● | | | | | ● | ● | ● | |
| | | | ● | | | | ● | | | 3 |

**Notes:** 
1. Unique iPhone and iPad versions are available.
2. Can export file at resolution higher than original image.
3. Export file resolution is less than camera resolution.
4. Can save alternate file types (PNG or TIFF).

# 38. Sequencing Apps

Now that you understand the types of apps and effects available, it's time to get creative and combine them. The simplest way to edit with multiple apps is to sequence them, taking the output from one app and processing it in another app. I have a simple sequence which can be followed to create interesting pieces of art from photographs:

**Clean It Up**—Fix the photo by making basic global adjustments, such as brightness and contrast, and by removing distracting elements by retouch, clone, or crop.

**Mess It Up**—Use color filters and textures to add variation and imperfection.

**"Paint" It**—Use artistic and digital apps to further alter the photograph. The variation

▲ The starting image.

▲ **1.** Handy Photo is used to remove a distraction in the trees.

▲ **2.** iColorama is used for an interesting line effect and subtle color.

▲ **3.** Stackables is used to alter color, texture, and masking.

▲ *Winter's Eve* (apps: ProCamera, Handy Photo, iColorama, Stackables).

and imperfection added in step 2 makes the final product more interesting.

Steps 2 and 3 can be reversed, or you can go back and forth between these steps.

## Unique Looks

In iPhone photography, the combination of apps and sequences you favor will lead to a unique style in your work over time. Even within your own work, you may find that you choose different apps and sequences depending on your evolving moods or interests. The range of styles that emerge from variation and experimentation with app sequencing is part of the fun and creativity to be found in this medium.

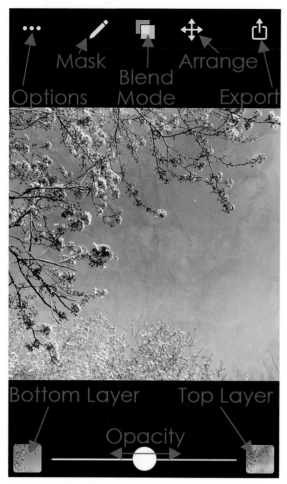

▲ Image Blender main screen.

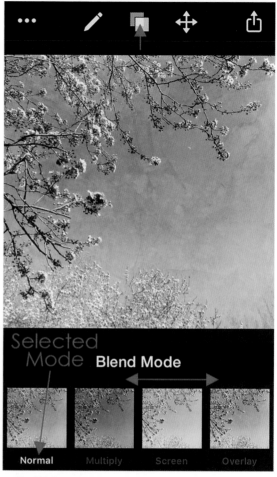

▲ Blend Mode menu.

Sequencing adds incredible variety to post-processing, but it's blending multiple images where the magic truly happens. Blending is when you take two images, either two distinct images or two variations on the same image, and combine them. Image Blender, Superimpose, and Union are all popular blending apps.

## Image Blender App

Image Blender is my favorite app for blending images. The first thing you do in Image Blender is load two images. Tap the left image icon to load the bottom image, or layer, of the stack; tap the right icon to load the top layer.

Once you have two images loaded, the initial settings are always Normal blending mode at 50 percent opacity. Use the opacity slider to adjust the effect of the blending

mode. To change the blending mode, tap the Blend Mode menu icon. Slide the menu left to right to view the options and tap a mode to preview it on the screen. When you have selected a mode, tap the Blend Mode menu icon again to close the menu and apply the selected mode and continue with opacity adjustments.

When you like the effect, tap the Export icon to save or slatten your image. For both Save and Flatten, the app applies the blend mode settings, combining the two images into one new image file. With Save, the new image file is exported to your Camera Roll and the original top and bottom images are still available in the app. This works well if you want to continue experimenting with blend modes on the same set of images. With Flatten, the two images are combined into the bottom layer in the app. This works well if you want to load a new image to the top layer. I first save each blended image so I have it available for future use, and then flatten if I want to blend another layer.

▼ *Springing It on Me* (apps: ProCamera, Snapseed, XnView Photo FX, Distressed FX, Repix, Image Blender).

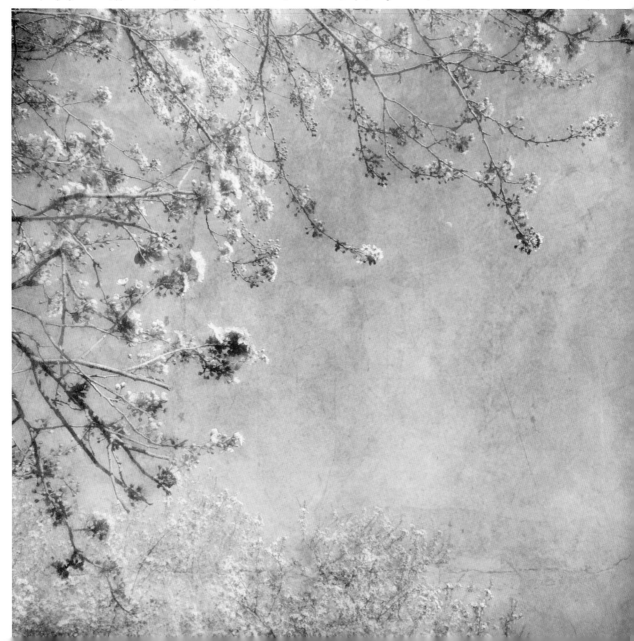

While blending creates wonderful effects, you may not always want to blend two images in their entirety. When that's the case, you can take advantage of the Mask and Arrange functions within the Image Blender app.

## Mask Function

To prevent part of the top layer from blending with the bottom layer, use the Mask function. Tap the Mask icon to open the menu. Using your finger, paint over the image to define the mask, which removes the top layer so it will not blend with the bottom layer. If

you find you have masked (eliminated) too much, tap the Mask/Erase icon to switch between the Mask and Erase modes. Then use the eraser to fill back in the erroneously masked areas.

For finer control of the mask, you can adjust the Brush Size and refine the Brush Type in their respective menus.

## Arrange Function

When the top image is not at the right size—or at the preferred orientation—relative to the bottom image, you can use the Arrange function to make adjustments. To quickly ad-

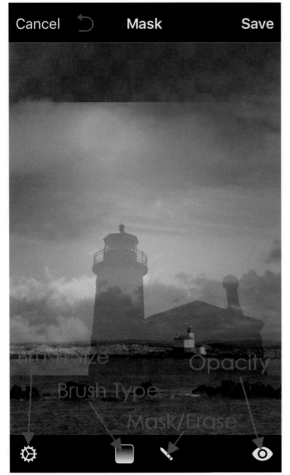

▲ Image Blender Mask Screen.

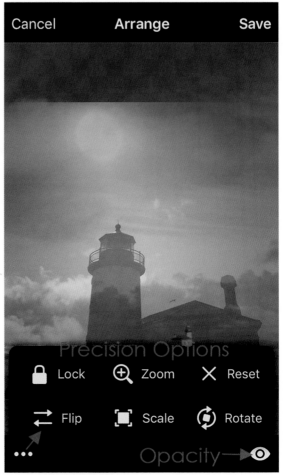

▲ Image Blender Arrange Screen

▲ *Coquille River Sun* (apps: ProCamera, Stackables, Snapseed, Pixlr, Image Blender).

just the top image, tap the Arrange icon and use two fingers to move, enlarge, or reduce the top image relative to the bottom image. Tap the More Options menu at the bottom to access additional functions such as flip (horizontal only), lock, and precision scaling or rotation.

## Opacity Adjustments

In both Mask and Arrange menus, the Opacity icon allows you to adjust the opacity of the images within the menu, so you can see what changes you make to the top image relative to the bottom image.

## Resetting Mask and Arrange

The Mask and Arrange settings will persist throughout a session, but you can easily reset these settings. Tap either the top layer or the Options menu, select Reset and then choose to reset either Mask or Arrange.

# 41. Blending Modes Explained

Blending modes are not random. They are mathematical functions which combine the pixels of two stacked layers to create a visually altered result, but you don't need to know the math behind blending modes to learn and control their visual impact.

## Top or Bottom?

In most cases, the visual result of a blend will vary depending on which layer is at the top or bottom. To test this, select any blending mode (except Normal) and set the opacity to 75 percent. Save the results. Now switch the

▲ **1.** Branch in bloom.

▲ **2.** Close-up of flowers, blurred.

▲ **3.** Image 1 on bottom, Lighten mode at 75 pecent.

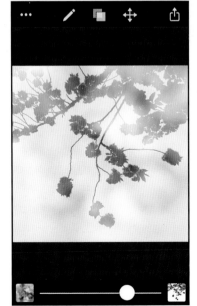
▲ **4.** Image 1 on top, Lighten mode at 75 percent.

▲ **5.** Switching top and bottom images.

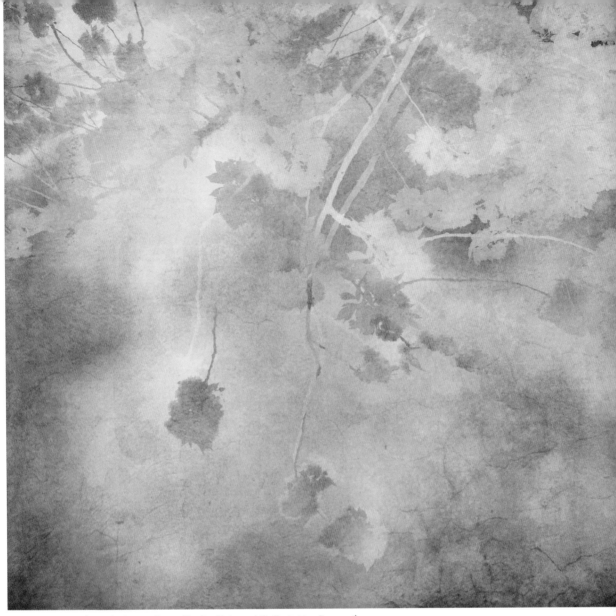

▲ *Spring on Paper* (apps: ProCamera, Image Blender, Distressed FX, Stackables, Snapseed).

images and save again. Compare the two images. Do you see the difference?

## Switch the Layer Order

To quickly switch the top and bottom images, access the Options menu at the top of the screen and tap Switch. The current blending mode and opacity settings are retained, but the images are switched between top and bottom layers.

## Variations and Refinements

The variety of results you can achieve with blending modes is fantastic. There are eighteen blending modes within Image Blender to start, and you almost double that when you consider that switching the top and bottom layer produces a different result in seventeen of the modes.

# 42. Blending Modes: Lighten/Darken

▲ Starting image, top layer.

▲ Starting image, bottom layer.

There are blending modes that primarily lighten or brighten an image and others that primarily darken an image.

For Lightening blending modes, the pixels of the bottom layer are lightened based on the lightness of the pixels of the top layer. There are four lightening modes in Image Blender, listed in order of increasing effect: Lighten, Screen, Plus Lighter, and Color Dodge. Color Dodge is the most extreme effect of the four, significantly increasing the color saturation and contrast, as well as lightening. You can also use these modes to add a subtle texture by using a texture image as the top layer.

For Darkening blending modes, the pixels of the bottom layer are darkened by the relative darkness of the top layer's pixels. The

▼ Lighten blending mode at 75 percent opacity.

▼ Color Dodge blending mode at 75 percent opacity.

▶ *Silent Communication* (apps: ProCamera, Glaze, AutoPainter II, Image Blender, Decim8).

four darkening modes, in order of increasing effect, are Darken, Multiply, Plus Darker, and Color Burn. Similar to Color Dodge, Color Burn intensifies the colors as well as darkening. Use these modes to darken and intensify the colors in an image. You can also add dramatic texture by blending a photograph as the bottom layer with a texture image as the top layer.

▼ Darken blending mode at 75 percent opacity.

▼ Color Burn blending mode at 75 percent opacity.

# 43. Blending Modes: Contrast

▲ Bottom layer.

▲ Top layer.

▲ Soft Light blending mode.

▲ Overlay blending mode.

◀ Hard Light blending mode.

Soft Light, Overlay, and Hard Light are the modes to use when you want to increase the contrast, or overall range of light and dark, of an image. In these modes, for the lightest of the pixels in your top layer, you lighten the pixels in the bottom layer. For the darkest of the pixels in your top layer, you darken the pixels of the bottom layer.

These modes are the typical modes you would use to blend an original with a texture image because you get the effect of the texture without dramatic shifts in color. As an example, the images here show the resulting blend of a photographic image on the bottom with a texture image on top. The opacity was set to 75 percent. The texture image was created by photographing a cracked plaster wall.

Don't restrict yourself to using these blending modes with textures only. The Contrast modes also works great when blending variations of the same image together.

▲ *Lighter Than Air* (apps: Slow Shutter Cam, Handy Photo, Snapseed, XnView Photo FX, Image Blender, Distressed FX, AutoPainter II).

# 44. Blending Modes: Shifting Color

▲ Bottom layer.

▲ Top layer.

For more dramatic and surprising effects, use the blending modes to shift the color. In this category, I include two comparative blending modes (Exclusion and Difference) as well as the color blending modes (Hue, Saturation, Color, and Luminosity).

Color blending modes are useful when you want the blend to affect one attribute of color (hue, saturation, or luminosity) without affecting the others in an image. Hue is the color value (red, blue, green, etc.). Saturation is the intensity of the color. Luminance is the brightness, or relative lightness/darkness of a particular color, ranging from black (no brightness) to white (full brightness). In each of the four color blend modes, you take some aspects of the color attributes from the top layer and the others from the bottom layer.

The comparative blending modes, Exclusion and Difference, transform color by in-

▼ Hue blending mode.

▼ Saturation blending mode.

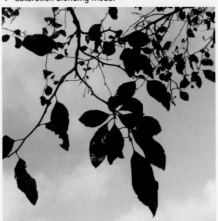

▼ Color blending mode.

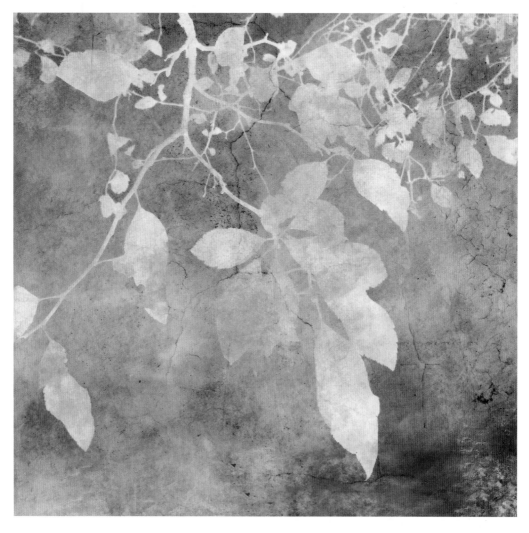

verting the colors of the bottom layer relative to the colors of the top layer. For the most intense color-shifting effect, use these modes with two different images rather than the same image blended on itself.

The examples shown here blend two different starting images in the four color blend modes and the comparative modes. The opacity was set to 75 percent.

▼ Luminosity blending mode.

▼ Exclusion blending mode.

▼ Difference blending mode.

Now you know the basic building blocks of creating photography-based iPhone art: a photograph, photo editing apps, and blending. You can combine these building blocks in infinite ways, which keeps the process fun and spontaneous—and makes the resulting art unique. Let's walk through the creation of *Good Evening* (below), so you can see how a finished image is built from the three basic components (facing page).

First, I played with the image in editing apps. As I try different options, I usually find myself pointed toward a mood, color scheme, or effect that fits the image. In this case, I was attracted to shades of gold and pink (1, 2, and 3).

Next, I sequenced the apps, to add texture and variation by the application of multiple effects (4 and 5). I blended these different sequenced versions together using Image Blender (6 and 7).

To complete *Good Evening*, version 7 was blended with version 1, which brought back the photographic structure of the trees while keeping the color and texture created through the editing sequence. The subtle color and texture variations are only achieved through the combination of sequencing and then blending multiple versions.

▼ *Good Evening* (apps: ProCamera, Pixlr, Glaze, Aquarella, Distressed FX, Image Blender).

► The original photograph, as composed and exposed with ProCamera *(left)*.

► **1.** Distressed FX *(right)*.

► **2.** Aquarella *(left)*.

► **3.** Pixlr *(right)*.

► **4.** From Pixlr into Glaze *(left)*.

► **5.** From Aquarella into Distressed FX *(right)*.

► **6.** Version 1 blended with version 4 *(left)*.

► **7.** Version 6 blended with version 5 *(right)*.

# 46. Creating Texture Depth

One of my favorite things to do is combine multiple texture apps through sequencing or blending, which creates a striking result. The piece *Imminent Downfall* (below) is a good example of how quick and easy it is to achieve this type of texture effect.

The image started as nothing exceptional, a photograph of an autumn tree. I liked the curving lines of the lower branches, but because there is no zoom lens on the iPhone,

this was the closest photograph I could get to those branches.

I used Snapseed to crop, lighten, and adjust the color with the Grunge filter (1). After cropping significantly like this, it is good to increase resolution in Big Photo before continuing to alter the photograph.

▼ *Imminent Downfall* (apps: Pro Camera, Snapseed, Classic Vintage Photo, Waterlogue, Image Blender, XnView Photo FX)

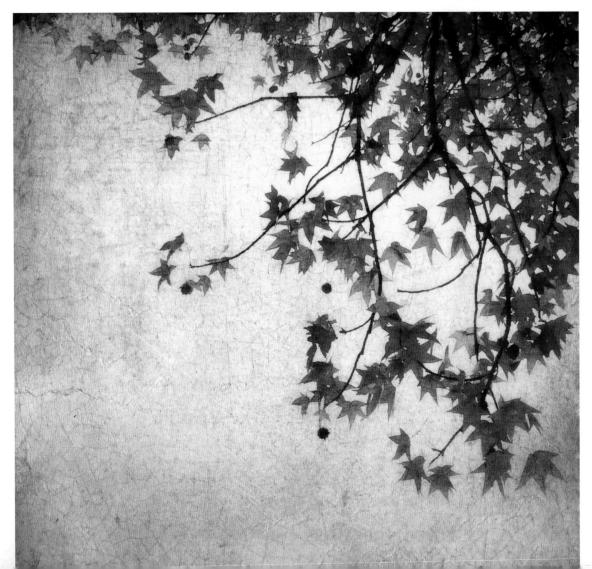

▶ The original photograph, composed and exposed with ProCamera.

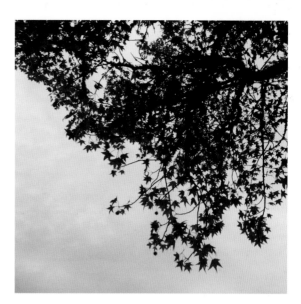

After playing with a few options, I liked the color contrast of the leaves against the background in version 3. To soften the edges and add a subtle color-bleed effect, I blended it with the output from Waterlogue (2). This also brightened the color in the leaves.

For an even stronger texture and to warm the image, I added a crackle texture using XnView Photo FX. The result was a complex and interesting texture.

▲ **1.** Snapseed.

▲ **2.** Version 1 through Waterlogue.

▲ **3.** Version 1 through Classic Vintage Photo.

▲ **4.** Version 3 blended with Version 2.

# 47. Creating Possibility

My process for creating art with iPhone photographs does not rely on a logical or predetermined sequence of steps. Most of my work involves creating possibilities for a piece by using multiple apps, then following one of the many branching paths. I may get several steps down a path and realize it's a dead end, go back to a previous point, and move off in a different direction. It's only at the end, when I have a finished piece, that I

▼ *Dissolution* (apps: ProCamera, Snapseed, Decim8, Image Blender, Lumiforms).

> "Most of my work involves creating possibilities for a piece by using multiple apps . . ."

can trace a clear path from the original to the final image.

After altering the color and texture in Snapseed (1) and Distressed FX (2), I explored options in Decim8. Since Decim8 effects are random, you can create possibility by

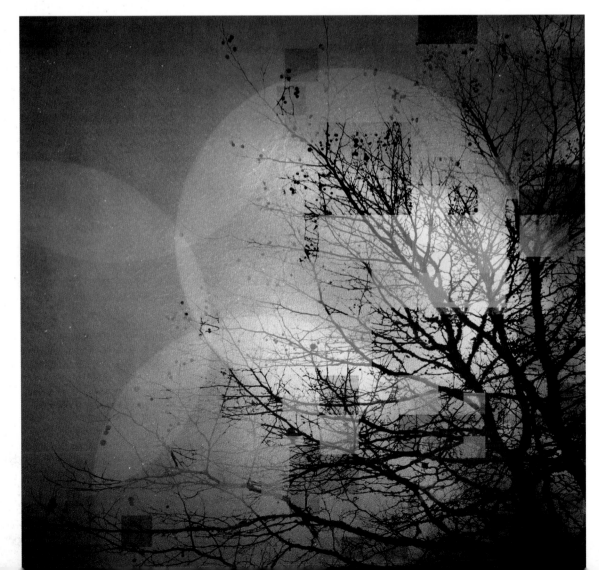

running the same effect multiple times. When a result looked interesting, I saved it and repeated the process. I selected one of the many options for continued blending (3). I blended this image back with version 1, creating and saving multiple versions with different blend modes to create more possibilities, one of which is the black & white version (4).

To complete *Dissolution* (facing page), I combined version 4 with a separate background image file (see the next section).

▲ The original photograph, composed and exposed with ProCamera.

▲ **1.** Snapseed was used to convert to black and white and increase contrast.

▲ **2.** Version 1 through Distressed FX to add texture and color.

▲ **3.** Version 2 through Decim8.

▲ **4.** Version 1 (bottom) blended with version 3 (top), Luminosity blend mode.

# 48. Creating Backgrounds

Now that you have the basics of sequencing and blending apps down, I'll share a few of the more unusual techniques I use in creating my iPhone art. One component in many of my images is a background that is created separately from the main image. To be used as a background, an image should consist mainly of subtle texture and color variations instead of a distinct subject.

The background for *Vanishing* (facing page) started as a texture image file. You can find textures online or create your own files

> "I use color filters and artistic apps to alter the texture image, just as I would a photo, smoothing out any sharp edges and adding some nice variations . . ."

by photographing various surfaces, such as concrete, paint, screens, etc.

▲ Texture image processed through Glaze (A), PhotoArtista–Oil (B), and AutoPainter II (C).

▲ Completed background.

▲ Photograph, created separately.

Next, I use color filters and artistic apps to alter the texture image, just as I would a photo, smoothing out any sharp edges and adding some nice variations from different apps. Multiple versions of the same image are blended together to create the background. Once created, backgrounds can be reused multiple times.

To achieve the effect shown in *Vanishing*, I used a black & white tree image blended with

▲ *Vanishing* (apps: ProCamera, Image Blender, Glaze, AutoPainter II, Handy Photo, Decim8).

a background. The tree was the top layer, arranged off center, and the background was the bottom layer, blended with a darkening mode (such as Color Burn). The horizontal lines were created by processing the blended image with the Decim8 app.

# 49. Using Backgrounds to Alter Color

The complexity achieved by blending multiple images and textures together can take a photograph from flat to nuanced and interesting. Viewers are not sure what they are seeing—is it a photograph or something else? As a result, they look closely to discern the details.

To create *Layered Autumn* (facing page), I used three photographs: an autumn tree as background (A), a close-up of autumn leaves

from a different tree as detail (B), and a cracked plaster wall as texture (C).

The background image was created from the autumn tree image (A) by sequencing and blending multiple artistic apps. This new background image suggested an autumn tree, retaining the color and rough structure without the distinct edges.

The leaf close up (B) was the top layer blended with the background (A) as the

▲ The starting images.

▲ The background image.

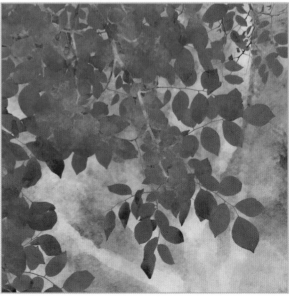

▲ Image B blended with the background image in Exclusion mode.

▲ Layered Autumn (apps: ProCamera, Portray, AutoPainter II, Aquarella, Image Blender, Snapseed).

bottom layer using the Exclusion mode. Because the colors of the bottom layer are most altered where they are different from the top layer, the leaves retained a yellow-red color while the sky shifted to a complementary color. I next blended the cracked plaster wall (C), along with additional texture files, increasing the color and texture variation.

# 50. Out-of-Focus Backgrounds

An out-of-focus photograph is another way to achieve a soft, subtle effect for a background image. In the image *Dyed for Spring* (facing page), a blurry photograph of tulips serves as the background image for the tulip silhouette.

Creating an out-of-focus image with an iPhone is not easy, since almost every camera app has autofocus built in. You can use the F/E Lock in ProCamera to override the autofocus for a blurred image or you can apply multiple blur layers in Stackables. In this case, I used an aftermarket macro lens.

I blended the silhouette tulip (bottom layer) and out-of-focus background (top layer) using the Exclusion mode at less than 100 percent opacity. This allowed some of the color variation from the background to be retained in the open space of the silhouette image. I arranged the background image so that the blurry tulip shape in the background overlaid the tall, focal point tulip. This creates a harmonious result as the shapes from the background replicated the shapes in the silhouette image.

The final image was achieved by blending multiple textures, which affected the color as well as texture of the image. While you can always use texture apps to add and blend in these additional layers, I also use Image Blender with individual texture files I've created or collected. Having multiple sources of textures adds variety and interest to your work over time.

▲ The two starting photographs.

▲ Arranging background relative to the silhouette.

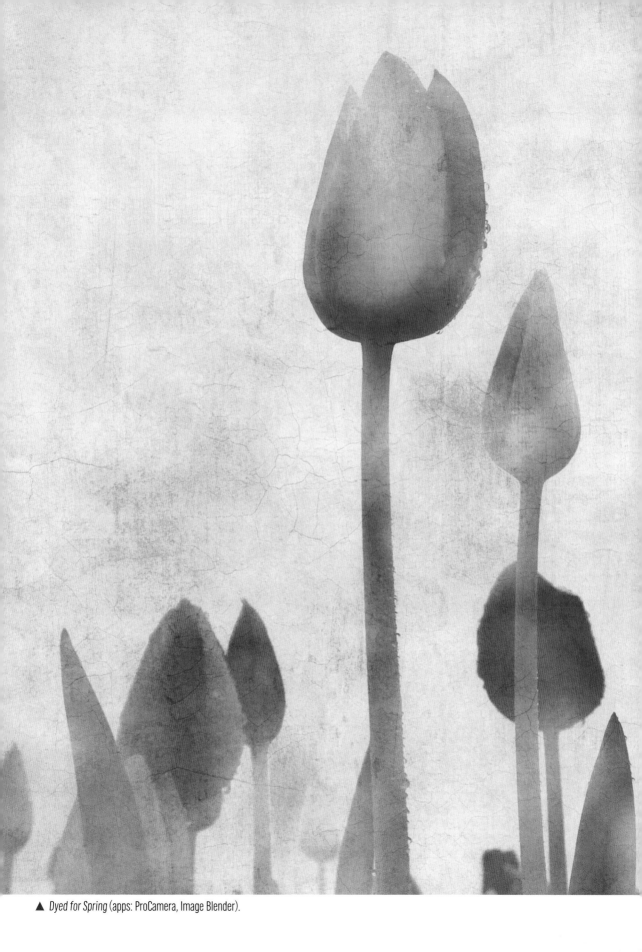

▲ *Dyed for Spring* (apps: ProCamera, Image Blender).

# 51. Bleeding Paint Effect

Are you convinced yet of the magic of blending? If not, *From One Season to Another* (below) demonstrates how blending creates imagery completely unlike a photograph—and unlike the output from any one app. The delicate structure of the leaves along with the colorful, painterly bleed can only be created from this sequence of blending, discovered through experimentation. Magic!

The first post-processing step was to brighten and enhance the color of the autumn leaves in Snapseed (1). Next, the photograph was processed through several apps (2, 3, 4), providing the base images for the blending sequence.

All straightforward so far! Now, on to the exciting part. Version 2 (bottom layer) was blended with Version 4 (top layer) using the Difference mode in Image Blender (5). Unfortunately, the image lost all of the original color, which was what attracted me in the first place. To get the color back and to further combine effects, I blended it (5, bottom layer) with the Waterlogue version (3, top layer) using Lighten mode (6).

To complete the piece, I cropped version 6, focusing on the area of most interest, and continued through additional apps to add texture and color variation to the background of the image.

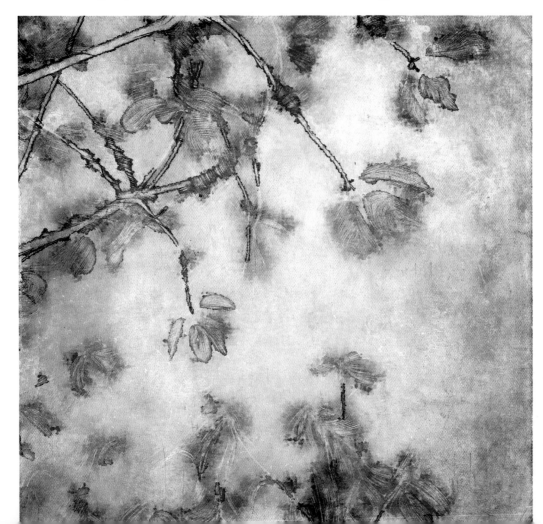

◄ *From One Season to Another* (apps: ProCamera, Snapseed, Tangled FX, XnSketch, AutoPainter, Waterlogue, Image Blender, Stackables).

▲ **1.** Brighten and enhance color in Snapseed.

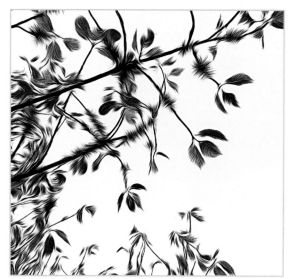

▲ **2.** Version 1 through Tangled FX.

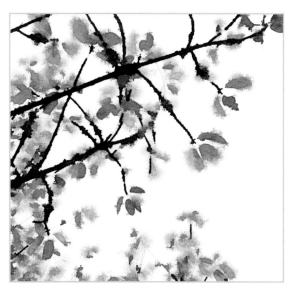

▲ **3.** Version 1 through Waterlogue.

▲ **4.** Version 1 through XnSketch.

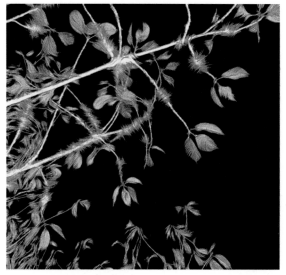

▲ **5.** Version 2 blended with 4.

▲ **6.** Version 5 blended with 3.

# 52. Woodcut Effect

Ilove the strong graphic black and vibrant color of woodcut print making. I discovered I could create a similar effect in my work, by combining an artistic black and white effect from iColorama with comparative mode blending in Image Blender.

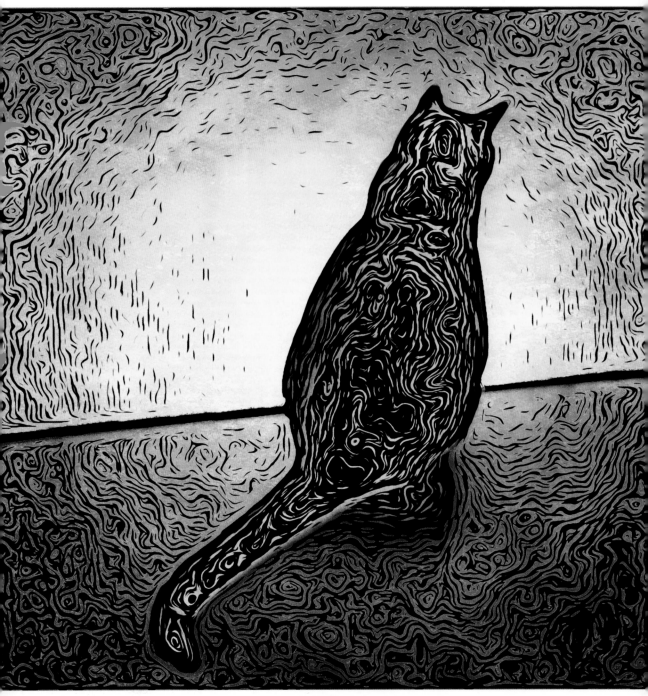

▲ *Watching Roman* (apps: ProCamera, Superimpose, Handy Photo, Stackables, iColorama, Tangled FX, Image Blender).

▲ The starting image was blurry and had lots of distractions.

▲ **1.** I cleaned up the image by removing the background in Superimpose and cloning additional foreground in Handy Photo. I increased the resolution in Big Photo.

▲ **2.** Color and texture were added in Stackables. The color selected in this step will greatly affect the colors at the end of the sequence.

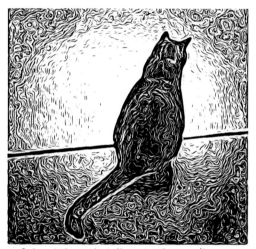

▲ **3.** I created a woodcut effect using iColorama (Style > ET-Flow > Preset 3). Use the settings to adjust the thickness, concentration, and swirl of the lines. Tangled FX can be used after this step to smooth any jagged lines.

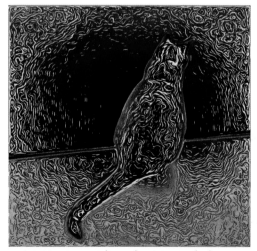

▲ **4.** I blended image 2 (bottom) with image 3 (top) in Image Blender, using the Difference mode at 100 percent opacity.

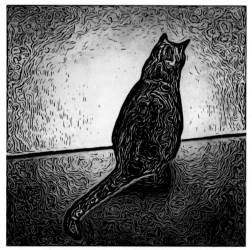

▲ To get the finished image, I blended image 2 (bottom) with image 4 (top) in the Difference mode at 100 percent opacity.

# 53. Warped Earth Effect

Creating a story from imagery is a way to tap into fundamental human emotions. *True North* (facing page) is an example of a piece that uses the manipulation of elements to tell a story. A human figure, the edge of the continent, and a bright star. Is the story bereft or hopeful? That's up to the viewer to decide.

▲ Starting photograph.

▲ **1.** The figure was cut from the edge of the frame, then moved and enlarged in Handy Photo. A color filter and space overlay were then added in Pixlr.

▲ **2.** In order to get a rectangular image out of the Circular app (next step), the starting image must be rectangular, so the original square was blended with a random rectangular photo on my camera roll.

▲ **3.** The image was warped in Circular.

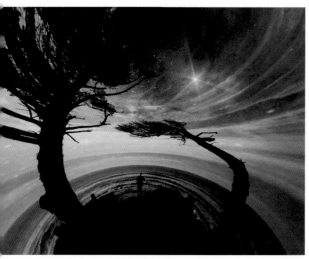

▲ **4.** A star and color filter were added in Alien Sky.

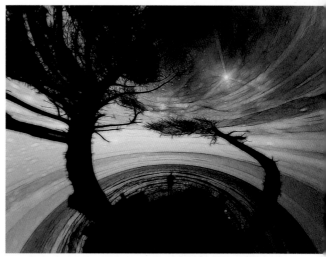

▲ **5.** I processed the image in Tangled FX to get additional definition on the curving lines in the sky.

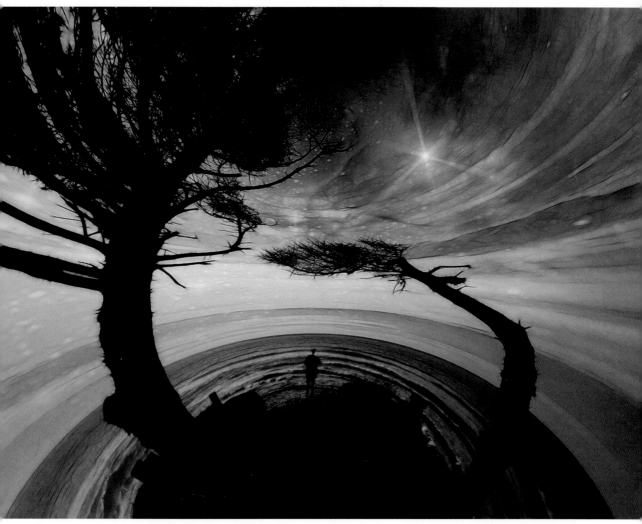

▲ The final step was to blend image 5 (bottom) with image 4 (top) using Luminosity blend mode in Image Blender. The figure, land, and waves were masked to keep the original image structure intact. *True North* (apps: ProCamera, Handy Photo, Pixlr, Circular, Alien Sky, Tangled FX, Image Blender).

# 54. Elements from Masking

While Image Blender is a fantastic app, other apps have built-in blending or masking functionality that can help you cre-ate interesting images. *Gatekeeper* utilizes the layer masking function in Stackables to create the appearance of a portal to another sky.

▲ Starting photograph.

▲ **1.** Texture and Color Gradient layers were added in Stackables.

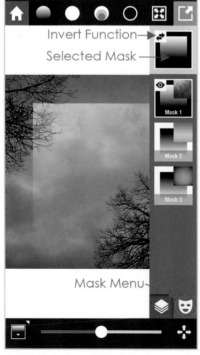

▲ **2.** In Stackables, switch to the Mask menu and add the same mask to each layer. The top layer mask is inverted relative to the underlying layer masks.

▲ **3.** Output from masked layers in Stackables.

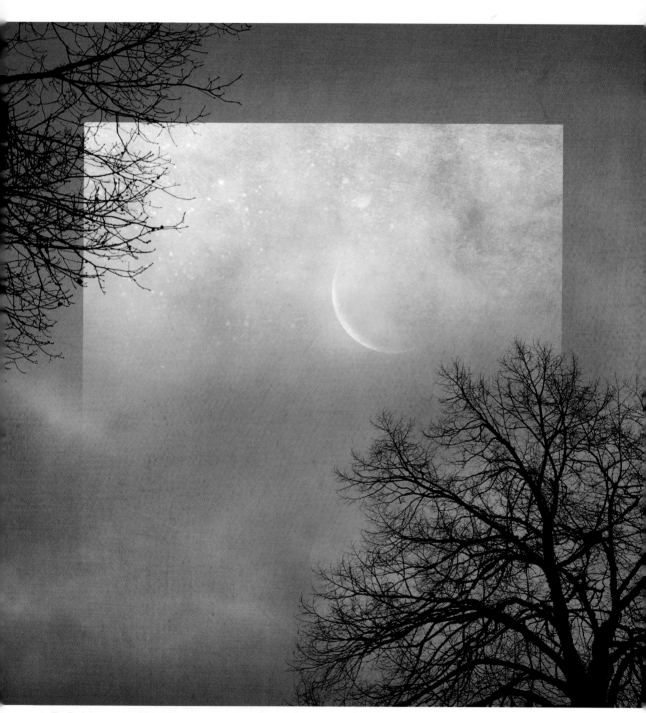

▲ The final step was to add the moon and stars in the portal using the Alien Sky app. Layers and masking were used in Alien Sky as well, to keep the stars from showing outside the portal. *Gatekeeper* (apps: ProCamera, Stackables, Alien Sky).

# 55. Cut and Move an Element

Sometime, you want to extract a specific element from a photograph for use separately. Both Handy Photo and Superimpose apps have functions to cut out elements.

## Handy Photo Move Me

The Handy Photo Move Me function is a great starting point for cutting elements. To start, use the Lasso to outline the element you want to cut. Then tap the Autoselect icon to have Handy Photo automatically select the element. Autoselect works best when your element has a good contrast with the background and large features. If portions of

"The Handy Photo Move Me function is a great starting point for cutting elements."

the element aren't correctly highlighted after Autoselect, manually use the Brush and Eraser to refine your selection.

## Moving or Duplicating

Once your element is correctly highlighted, tap the Move icon to move to the next menu.

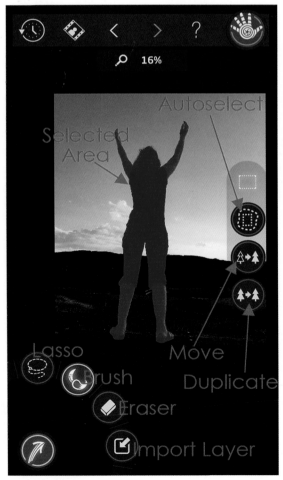

▲ Handy Photo Move Me main screen.

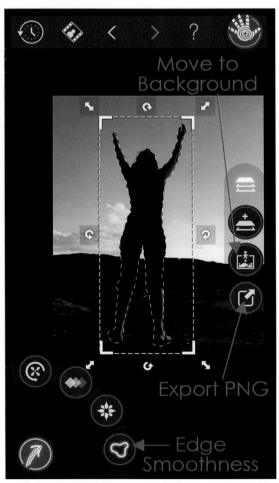

▲ Move Me export screen.

Handy Photo will process your selection, and then you can choose how to layer it. You have the option to export the selection with a transparent background (PNG file) or move it to a new background image. If you choose Move to Background, the selection is placed on the background, where you can arrange and resize as desired.

If you discover you have stray elements or you missed part of your selection, use the Undo feature in Handy Photo to go back and adjust your selection, then Move again. You can go back and forth through this procedure, fine-tuning the selection and reviewing the results on a blank background until you are ready to commit the Move by saving the image to the Camera Roll.

## The End Result

At the end of this procedure, you have an image of a specific element, with either a transparent or selected background, which can be processed further in editing apps or combined with other layers in Image Blender.

▲ *It's No Stretch* (apps: ProCamera, Handy Photo, Superimpose, iColorama, Stackables).

# 56. Collage From Multiple Images

Now that you know how to cut elements from a photograph, you can remove and combine elements from different photographs to create more conceptual collage art. Collage is a different type of art-making, using disparate elements to create a composition or tell a story. You can collect images for possible use in a collage in the future, or take images specifically for an image. That's what I did for *She Owns Her Time* (facing page), which uses elements from six different images.

▲ The base layer is an accidental image, taken in my pocket. Even accidents can be used when you are creating art!

▲ This calendar image was blended with the background.

◄ Additional textures were blended with the layered image to add more variation.

▲ The layering elements were cut from four different photographs. The human figures were photographed in silhouette against a sky to make them easier to cut out.

▲ To create the final image, the cut elements were layered one at a time on the background, starting with the clock, the clock hands, and then the figures. Mask and Arrange were used in Image Blender to precisely place each added element relative to the rest of the image. She *Owns Her Time* (apps: ProCamera, Superimpose, Handy Photo, Image Blender).

# 57. Cut, Invert, Layer: Frame

Once you cut an element out of a photograph, you can use that new element in different ways. In the image *Aspens*, a cut-out leaf became a frame for another photograph.

## Selecting the Element

I cut out the leaf, placed it on a white background, then converted it to black & white in Snapseed. I increased the contrast in the black & white version so the vein detail would be retained when I later blended the image.

## Invert the Image

The next step was to invert the black & white leaf image (making the white areas black and the black areas white). A few apps offer functions that invert color, but there is also a simple way to do this using Image Blender. Load the black & white image as the bottom layer and a plain white background as the top layer and blend using Difference blend mode with 100 percent opacity.

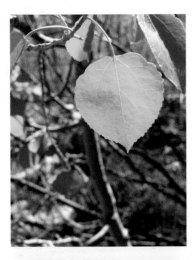

◀ **1.** Original leaf photograph.

◀ **2.** Cut out leaf.

◀ **3.** Inverting in Image Blender.

◀ **4.** Bottom image.

▲ *Aspens* (apps: ProCamera, Handy Photo, Image Blender, Snapseed, AutoPainter II)

## Blending

To finish, I blended the inverted image as the frame (the top layer) with another processed image of aspen trees (the bottom layer) using the Multiply blend mode with 100 percent opacity.

# 58. Cut, Invert, Layer: Background

▲ Circle Frame from Afterlight.

▲ Arrange and Invert in Image Blender.

With the techniques covered in this book, you have the tools needed to craft alternate realities for your photographs. The photograph is the raw material for a new creation. *Harvest Moon* is an example of how simple editing techniques can be used to suggest an experience—in this case, viewing the moon through a tree—on a scale that would be impossible to photograph.

## Afterlight: Cutting a Circle

To create the appearance of the moon, I needed a circle. Using the shape frames in the Afterlight app, with the frame color set to white, the result is as if I cut and layered a circle onto a white background.

## Image Blender

Afterlight centers the shape frame, so I used Image Blender and a white background to

▲ Final background.

arrange the shape off the edge of the frame in an artistically pleasing way—as well as to invert the image.

## Background Texture and Color

Blending with textures in Image Blender and Stackables lightened, colored and textured the black and white background.

## The Tree Image and Final Details

The final image is created by blending a black and white tree image with the background. Note that the direction of the light in the tree image serves to reinforce the impression of moonlight, since the moon is on the right side of the image.

When blending multiple images together, small details such as the direction of the light become important. To create an alternate reality that engages the viewer, it helps if the image has elements that are grounded in real experience.

▼ *Harvest Moon* (apps: ProCamera, Afterlight, Snapseed, Stackables, Image Blender).

Taking things a little further out of reality, you can use a silhouetted photograph to create the effect of cutout paper. *Sing Me a Blue-Green Moon* combines three elements: a created background, a photograph of trees, and the same circle shape background that was created for *Harvest Moon* (see section 58 for details).

The starting photograph provides the makings of a forest silhouette. A high-contrast, black & white image is required to create a cutout, so I cropped the forest scene,

▲ Starting photograph.

▲ Converted to silhouette.

▲ Paper cut-out.

▲ Cut-out blended with background.

▲ *Sing Me a Blue-Green Moon* (apps: ProCamera, Snapseed, Afterlight, Image Blender, Stackables).

converted it to black & white, and edited it to create a simple silhouette.

To achieve the paper cutout effect in Image Blender, I placed the silhouette as the bottom layer and the created background as the top layer, then blended them using Hard Light mode.

Before combining the paper cutout with the moon background, I converted the moon image to blue tones in Stackables. Then I blended the cut-out (bottom layer) and the moon background (top layer) in the Darken mode. In this blend, the moon was masked over the trees to create the impression it is behind the trees.

The blue tones of the background and foreground did not quite match, so my last step was to process the blended image in Stackables and create a harmonious blue-green color palette across the combined elements.

# 60. Prep for Sharing Online

Once you've finished creating your iPhone art, it's time get it off of your device and share it! The ease of sharing your art with others is part of the fun of iPhone photography. There is, however, one last step to consider before you share.

## Protecting Your Images

When you share online, you run the risk your files could be copied by others. If you are sharing art you intend to sell and want to remain attributable to you, it is good to add a watermark and reduce the resolution so that your art can't easily be reproduced as a high-quality print.

Before I share online, I use the Reduce app to reduce the image resolution and apply a watermark quickly and easily. From the Main Menu, set the maximum resolution, file size limits, EXIF data options, and sharpening. I typically reduce to <1000 pixels on the long side when I share online. This size works well across multiple social media platforms.

Tap the Settings icon to add your watermark or border, if desired. You are now ready to apply the settings to your photos. Tap the album that holds the photos you want to process. ( *Note:* The Camera Roll is always the album in the top left corner.) Tap to select your photos, then Start. New versions with watermarks and reduced resolution are saved to your Camera Roll.

## Your Turn

You're done! Can you believe it? As you've worked your way through this book, you

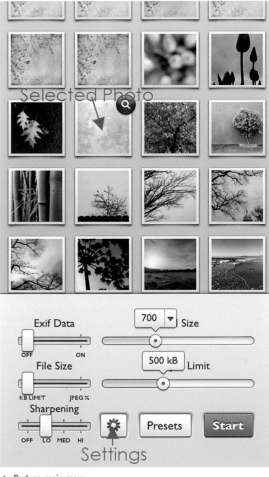

▲ Reduce main menu.

have gained the basic tools you need to create and share art with iPhone photography:

1. An understanding of the camera hardware, power, and file management techniques to keep your iPhone running well for photography.
2. Great camera apps to get the best photographs.

3. Basic editing apps to make your photographs even better.
4. Creative editing apps to alter your photographs in interesting ways.
5. Blending techniques to further transform your photographs into unique art.

Now, it's time for you to play and experiment on your own. Don't be discouraged if your photographs aren't instantly transformed into art when you apply these techniques. It takes time and effort to learn the tools and develop your own style. Keep working on it.

I'd love to see what you create! Tag your photos with @kateyeview on social media so I can find your work. Have fun creating your own altered realities!

▼ *Reverberate* (apps: ProCamera, Stackables, Image Blender, Reflect).

# Index